IMAGES
of America

SCOTTSDALE ARCHITECTURE

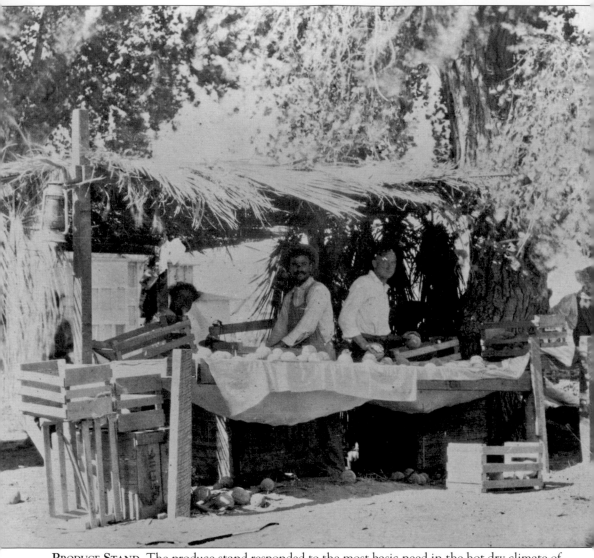

PRODUCE STAND. The produce stand responded to the most basic need in the hot dry climate of Scottsdale—shade. The palm tree fronds supported by the wood-framed structure filter the intense light while encouraging natural breezes on the open sides. (Scottsdale Public Library.)

ON THE COVER: The Scottsdale City Government Complex of 1968 was designed by Bennie M. Gonzales Associates and includes a city hall, the Civic Center Library, and extensive site improvements. It has become one of the most beloved and significant architectural achievements in Scottsdale. (Scottsdale Historical Society.)

IMAGES
of America
SCOTTSDALE
ARCHITECTURE

Douglas B. Sydnor

ARCADIA
PUBLISHING

Published by Arcadia Publishing
Charleston SC, Chicago IL, Portsmouth NH, San Francisco CA

Printed in the United States of America

Library of Congress Control Number: 2009932656

For all general information contact Arcadia Publishing at:
Telephone 843-853-2070
Fax 843-853-0044
E-mail sales@arcadiapublishing.com
For customer service and orders:
Toll-Free 1-888-313-2665

Visit us on the Internet at www.arcadiapublishing.com

To my family for their support and patience

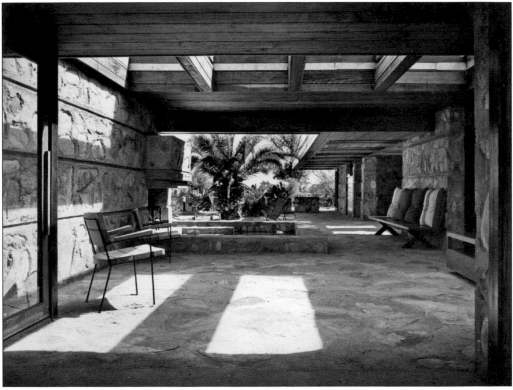

Louis C. Upton Residence, 1949. The 1949 Louis C. Upton residence with large doors opened onto an exterior patio defined by "desert masonry" walls, a fireplace, water feature, and floating redwood canopies above. It was designed by the architecture firm Schweikher and Elting with Paul Schweikher, FAIA, and contractor George Ellis. (Julius Shulman, Will Bruder + Partners, Ltd.)

CONTENTS

ACKNOWLEDGMENTS

I would like to sincerely thank specific individuals and archives that have provided access to some inspiring images and made the production of *Scottsdale Architecture* possible. They include JoAnn Handley, Scottsdale Historical Society; Leigh Conrad and Anna Quan Leon, Civic Center Library Scottsdale Room; Hannah Carney and Jared S. Jackson, Arcadia Publishing; and Pat Dodds, City of Scottsdale Communications and Public Affairs Office. Other noteworthy contributors are Janie Ellis; Barney J. Gonzales; Rita Hamilton, City of Scottsdale Public Library; Shelly Dudley, Salt River Project Research Archives; Tina Litteral and Diana Smith, American Institute of Architects-Arizona and Phoenix Metro Chapter; Brian Cassidy, Central Arizona Architectural Foundation; Debbie Abele and Don Meserve, City of Scottsdale Preservation Division; and Lois J. Fitch, First Church of Christ, Scientist.

Architects who provided support include Kenneth Allen, AIA; Mark Philp, AIA; John Kane, FAIA; Will Bruder, AIA; Wendell Burnette, AIA; Peter M. Koliopoulos, AIA; Jack DeBartolo III, AIA; John Blackwell, AIA; John Douglas, FAIA; Lawrence Enyart, FAIA; Trudi Hummel, AIA; David C. Hovey, FAIA; Wilson Jones; Eddie Jones, AIA; Neal Jones, AIA; Artin Knadjian, AIA; Jan Lorant, AIA; Edward B. Sawyer Jr.; Howell Shay III, AIA; Michael Shelor; Rafique Islam; Vern Swaback, FAIA; Morris A. Stein, FAIA; Jeremy Jones, AIA; and Philip Weddle, AIA.

Key individuals that offered invaluable advice including editing, verifying facts, and offering encouragement are Joan Fudala, Don Hadder, and Paul Messinger. I must also thank Josh Carter and my wife, Sonia, and my daughter, Elizabeth, as they assisted with editing and production.

This book provides an architectural sampling over the past 120 years, and if a particular project is not featured, it is due to a restricted number of images. This effort clarifies how important it is that we save and preserve our historical archives for future generations to better understand and appreciate our rich architectural heritage.

INTRODUCTION

Attempting to capture the evolution of Scottsdale architecture over the past 120 years is a daunting task. With roots in farming and cattle, there are relatively few images that record these earlier times, but it is richly rewarding to discover those few that are available and share them. Wherever possible, new discoveries have been pursued in the hopes of offering a perspective on our diverse architectural resources. As time moved along, the pace of development parallels the quantity and quality of photographs. Research showed that many sites, and particularly in downtown, have had up to five or six buildings constructed on them over the past hundred years. So when thinking about the specific history to tell, which historical layer or layers in this elaborate three-dimensional matrix should be told?

Since the late 1880s, the small farming village east of Phoenix, Arizona, that incorporated in 1951 as Scottsdale has evolved through its architecture. When incorporated the population was about 2,000 in 1 square mile and by 1955 had grown to about 3,500. An agrarian beginning brought about simple, utilitarian, and functionalist architecture, followed by early town buildings of the first grocery stores, pool hall, banks, blacksmith, post office, and schools.

Since incorporation, the City of Scottsdale and its citizens have consistently adopted various initiatives that have had a profound impact on the quality of the built environment. In 1953, an architectural board was formed to ensure adherence to the Western Revival theme in the hopes of drawing tourists and future residents, which proved effective until the early 1970s. As early as 1954, an ordinance to manage signs was adopted, followed by banning billboards in 1962. The 1970s instituted a landscape ordinance that required certain minimum design standards be met. It is these programs that set a very high aesthetic standard and is one of the reasons people have been attracted to Scottsdale. Within this supportive environment, the architecture reinforced these larger goals. The 1970s brought about the first design review board to review and approve all commercial development. Starting in 1964, the Scottsdale Town Enrichment Program (STEP) committee studied various and important public infrastructure improvements.

The enclosed material represents the architecture within the Scottsdale area. The intent was to share those that capture an era, highlight architectural styles and themes, the range of building types, and locations. In addition, there is a sampling of work from those architects who have been active and who have contributed positively to Scottsdale. Many featured projects have received professional design awards and have been recognized regionally and nationally.

This architectural story continues to evolve given various influences that shape it such as community expectations, the economy, and politics. Looking back, the architecture produced here reflected the community priorities and the contextual conditions of that specific time.

The future of Scottsdale appears committed to becoming more sustainable. Given Scottsdale's innovative past and the new national spotlight focusing on local architecture, it is ready to demonstrate how to develop projects in the harsh conditions of the Sonoran Desert and this unique climate.

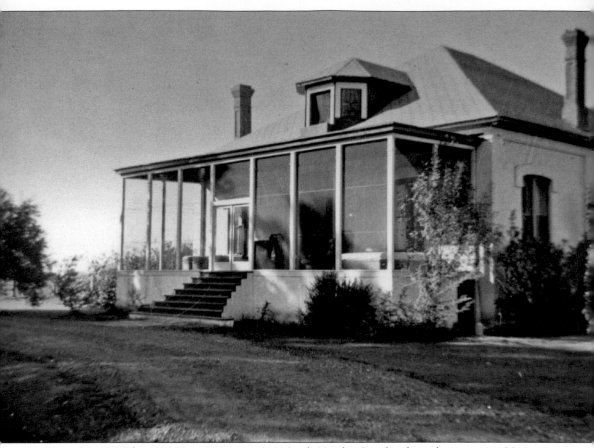

Titus House. The 1892 Titus House at 1310 North Hayden Road is the only remaining Victorian residence in Scottsdale. Character captured a street presence with the front steps, porch, and pitched roof dotted with fireplace chimneys. James Miller Creighton, a prominent Arizona architect of the era, designed the residence. (Scottsdale Historical Society.)

One

EARLY AGRARIAN AND TOWN BUILDING BEGINNINGS

1887–1951

The start of the 20th century attracted health seekers to Scottsdale's clean air, dry climate, and open-desert landscape. Their accommodations were very basic and included tent homes of wood framing and canvas and outdoor shade ramadas. Agricultural operations then got underway in 1885 with access to the Arizona Canal water. With the population growing, the need to socialize started various community events and buildings such as the first schools.

In 1924, a new main rail line connection in nearby Phoenix encouraged further growth and development in the area. During this time, Scottsdale grew slowly and steadily as it provided goods and services to farming ventures. The original Scottsdale town site reflected the traditional pattern of community development in the early 20th century and until the early 1930s.

During 1910 through 1919, the first major immigration wave occurred, bringing cotton growers from Texas and Oklahoma and cotton pickers from Mexico. During World War I, a national need for goods took place and had a positive impact on Scottsdale economy, such as cotton commanding a high price. It was also about 1915 when the preferred architectural styles took root, including Spanish Colonial Revival, Mission Revival, and Territorial. About 1920, a typical commercial-box style developed in downtown for the sale of goods and services. The 1920s was a quieter time for the community with a population of about 250. Cotton prices fell and negatively impacted the local economy. Farming refocused toward dairy herds and at a scale with other farming types that encouraged Scottsdale's first bank to open. The Depression arrived in the 1930s, which caused bank failures and private property foreclosures.

The early 1940s was preoccupied with World War II and established the Thunderbird Field Air Corps to train pilots and eventually became the Scottsdale Airport. The postwar era experienced a major construction boom to Scottsdale and the Greater Phoenix area. The architectural style in 1945 included California Ranch, as most evident with single-family residential subdivisions. Scottsdale incorporated as a town in 1951, and it started to see the rural farming lifestyle end.

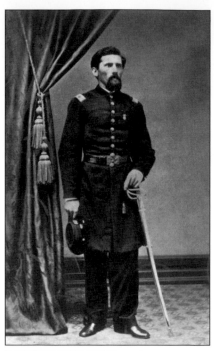

WINFIELD SCOTT PORTRAIT, 1862. As founders of Scottsdale, army chaplain Winfield Scott and his wife, Helen, bought acreage, planted citrus, settled in, and recruited others from the Midwest to come so they could prosper in Scottsdale. (Scottsdale Historical Society.)

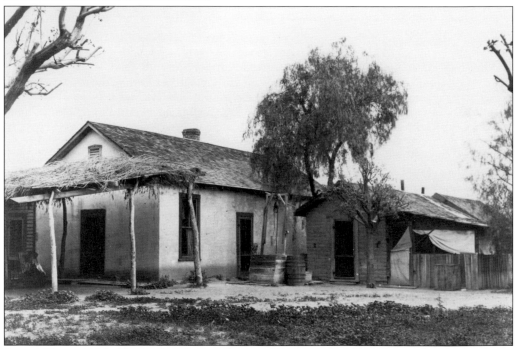

SCOTT HOME, 1895. The modest farming home of the Scott family was located at the northeast corner of Scottsdale and Indian School Roads within the property purchased by the Scotts. Farming included a wide range of crops such as citrus, grapes, figs, and many others. Winfield Scott sought advice from the Pimas and used plastered walls, a wood-framed roof, ventilated attic, recessed window openings, and a shade ramada. These features speak to the very pragmatic and utilitarian structures of early Scottsdale. (Scottsdale Public Library.)

ARIZONA CANAL, 1883–1885. The Arizona Canal was envisioned, developed, and constructed by William J. Murphy of the Arizona Canal Company, as it began in May 1883. It provided that critically important and most precious resource—water—to the Salt River Valley and to Scottsdale. Water access clearly initiated the development of this small rural farming community. (Scottsdale Public Library.)

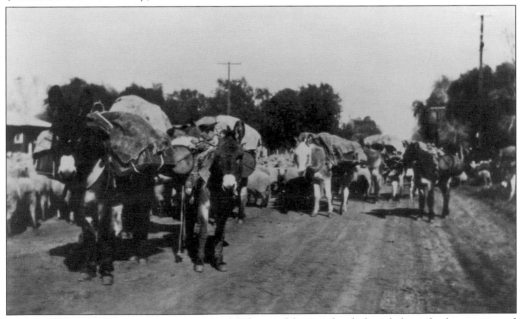

MULES, LATE 1930s OR EARLY 1940s. Mules and horses loaded with barrels, luggage, and tarpaulins are seen traveling up the unpaved Scottsdale Road. Mules were reliable transportation and packing animals used in the early 20th century for carrying goods. Other ranching operations included beef cattle, dairy cattle, hogs, and farms growing varying crops over the years depending on market demands. (Scottsdale Historical Society.)

TITUS HOUSE, 1920s. The 1892 Titus House is located at 1310 North Hayden Road within a citrus farm and breeding ranch for wealthy railroad investor Frank Titus of San Francisco, California. The one-story structure is an excellent example of the Victorian architectural style. It was constructed of brick walls, tall windows, a steeply pitched hip roof with dormer, fireplaces, and a screened front porch. This house, designed by architect James Miller Creighton, is the oldest Scottsdale structure and is listed on the National Register of Historic Places. (Scottsdale Historical Society.)

EARLY SCOTTSDALE, 1900s. Scottsdale in the early 1900s was a farming community with wide-open, uninterrupted spaces and a few signs of settlements, as tent homes and farm-maintenance facilities dot the landscape. (Scottsdale Public Library.)

GABE BROOKS POWDERHORN RANCH. This utilitarian ranch structure on the Gabe Brooks Powderhorn Ranch he started in 1917 was located on East Cactus Road and reflected a very pragmatic approach to the early architecture. Brooks was the area's primary water well driller. Note the board-and-batten siding; wood-framed, low-pitched roof; and overhang used to shed the rainwater and block out the severe sun. (Scottsdale Public Library.)

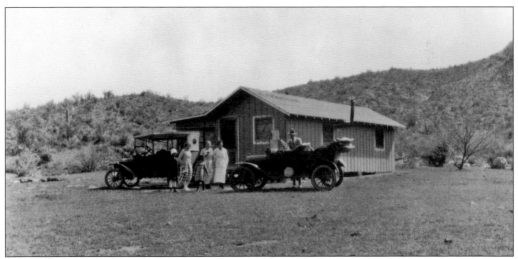

D. C. RANCH, 1920s. Members of the Edwin Orpheus Brown family lived in this ranch home located on the D. C. (Desert Camp) Ranch in the foothills of the McDowell Mountains. It is a slightly elevated wood-framed building with a low-pitched roof over the main structure and a shaded porch. (Scottsdale Public Library.)

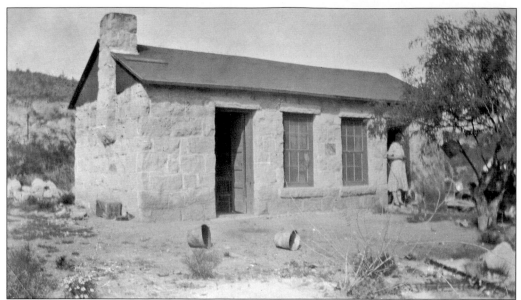

BROWNS ROCK HOUSE. Shown here at the Browns rock house, located on the D. C. Browns Ranch, stands Nora Smith in the doorway. Nora Smith was the wife of Jack Smith who eventually farmed 40 acres in south Scottsdale. The simple structure is composed of exposed stone walls and a fireplace chimney with a wood-framed, low-pitched roof. This construction method was a durable approach, given the use of stone rather than the typical ranch exposed-wood siding. (Scottsdale Historical Society.)

SALT RIVER PROJECT CAMP, 1944. The Salt River Project Camp, a subdivision of permanent housing units that was built by the Salt River Valley Water Users Association for those who maintained their facilities, was located at 6440 East Thomas Road for the Yaqui Indians. Exterior materials included masonry walls, a wood-framed roof, board-and-batten end gables, and steel-framed windows. This suggests residents being active outdoors, with growing flowers and vegetables. (Shelly Dudley, Salt River Project Research Archives.)

MESSINGER RANCH, 1943. Adobe buildings at this early dairy farm, Messinger Ranch, were located at 4033 North Miller Road. The main residence to the left still stands, but the ancillary structures have been removed. The residence has a low-pitched and wood-framed roof with a corner fireplace. (Scottsdale Public Library.)

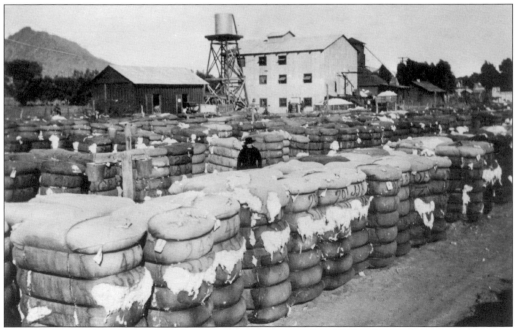

COTTON GIN, 1920S. Scottsdale Ginning Company opened in 1920 at Brown Avenue and Second Street to process Pima cotton. The structures are both wood framed and have pitched roofs with gable ends, but the left structure is clad in board-and-batten siding while the center structure has metal siding with operable windows. (Scottsdale Historical Society.)

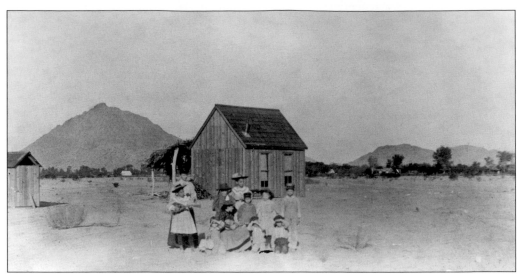

FIRST SCHOOLHOUSE, 1896. This one-room schoolhouse was located at Brown and First Avenues. Using wood framing, raised flooring, and walls of board and batten, residents built the structure in one day. The steeply pitched roof is reminiscent of Midwestern architecture, and Camelback Mountain is also shown in the distance. (Scottsdale Public Library.)

SCOTTSDALE GRAMMAR SCHOOL, 1909. Located at 7333 Scottsdale Mall, the one-story redbrick Scottsdale Grammar School has a full basement. The symmetrical plan with a hipped roof is characteristic of Victorian cottages and bungalows. Winfield Scott urged the construction of this substantial building to reflect Scottsdale's permanence, and A. H. Coats prepared the plans. It was placed on the National Register of Historic Places. (Scottsdale Historical Society.)

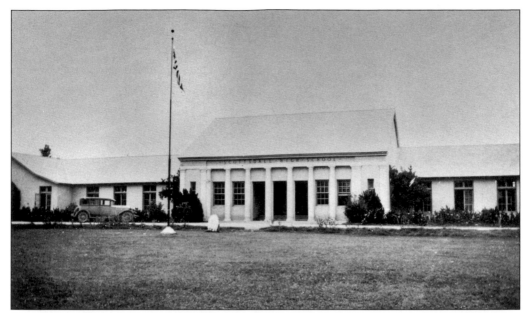

SCOTTSDALE HIGH SCHOOL, 1923. The Scottsdale High School was a very prominent edifice in the community and was intensely used for innumerable activities. This classically designed structure by Lescher and Mahoney Architects was constructed of wood-framed floors, plastered-brick walls, and a pitched, wood-framed roof. (Scottsdale Historical Society.)

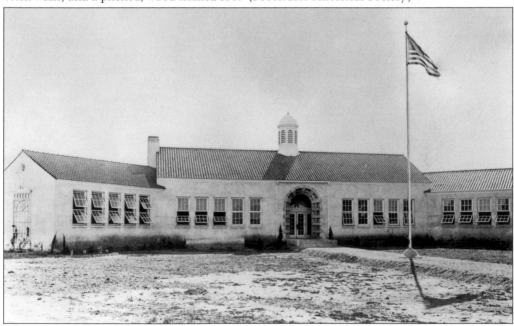

SCOTTSDALE GRAMMAR SCHOOL NO. 2, 1928. Located at 3720 North Marshall Way, the Scottsdale Grammar School No. 2 was designed in the Spanish Colonial Revival style by Lescher and Mahoney Architects. This stucco structure with a partial basement is most easily identified by low-pitched, red-clay tile and gable roofs. The original plan included eight classrooms and offices with a main building with projecting wings. The front facade provides an archway defined with a molded concrete trim. (Scottsdale Public Library.)

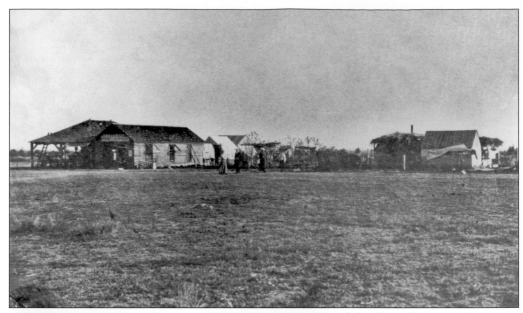

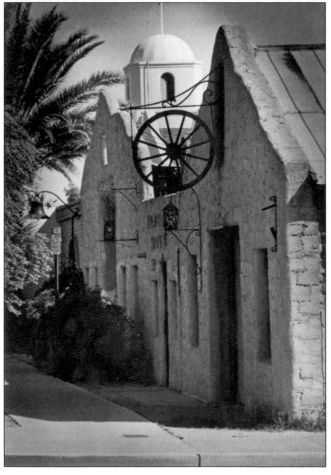

J. L. Davis General Store and Post Office, 1897. The J. L. Davis General Store and Post Office, Scottsdale's first general store and post office, was located at Brown Avenue and Main Street. It was believed to be the first wood-framed building, which was an expedient, affordable construction type. (Scottsdale Public Library.)

Cavalliere's Blacksmith Shop. The original 1910 tin building that housed Cavalliere's Blacksmith Shop is located at 3805 North Brown Avenue. Over time, it evolved into three building sections for the blacksmith operation and office. An addition was made to the rear, and later, the adobe walls were erected. Earlier years involved shoeing livestock and repairing farm equipment; later, the shop made ornamental iron used in many local homes and resorts. (Scottsdale Historical Society.)

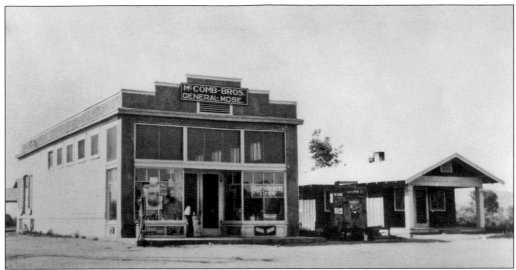

McComb Brothers Store, 1920s. The McComb Brothers store was at the southwest corner of Scottsdale Road and Main Street and housed a U.S. Post Office for Scottsdale citizens. Later uses included the Scottsdale United Methodist Church and Justice of the Peace during the 1930s and 1940s. The front facade was symmetrically composed with three windows and centered doors. The building's glazed front and stepped-roof profile provided an impressive street presence. (Scottsdale Public Library.)

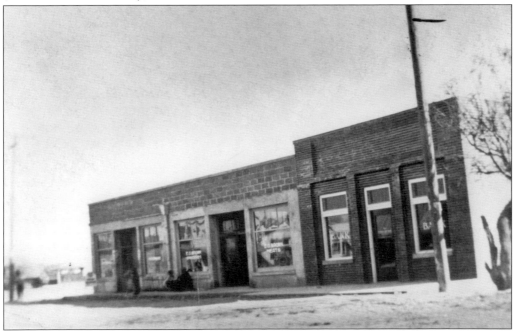

Farmer's State Bank of Scottsdale, 1921. The Farmer's State Bank of Scottsdale is located at 7245 East Main Street and is the brick building to the right. Brick corbelling ornaments the roof cornice, pilasters define the corners, and a glazed front addresses the street. E. O. Brown's General Store was to the left. Establishing local banks was a critical factor in the growth and development of a young town. Unfortunately, the bank closed in 1933 due to the Depression and became the Money Exchange in the 1940s. (Scottsdale Public Library.)

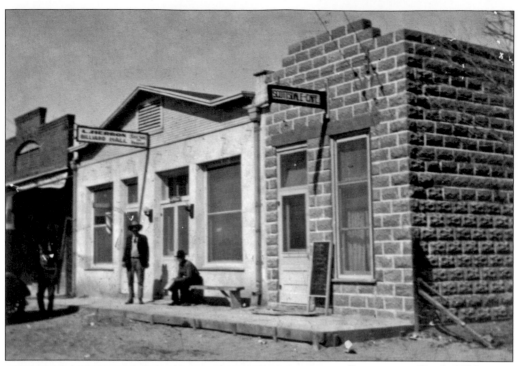

SCOTTSDALE CAFÉ, 1922. Herron's Billiard Hall is on the left, and the Scottsdale Café is on the right. Both buildings have symmetrical facades with the pediment front and stepped roof profile respectively. Contrasting wall materials differentiate the two establishments, while the glazed windows maintain a similar design. The café was operated by Clara "Pansy" Beauchamp in the 1920s. (Scottsdale Historical Society.)

GAS STATION, 1924. This early gas station was located at the southeast corner of Main Street and Brown Avenue and catered to servicing vehicles and providing gas pumps. Two structures with plastered walls and clay-tile roofs accommodated these uses. (Scottsdale Historical Society.)

U.S. POST OFFICE. The first freestanding post office of 1929 is located at 3944 North Brown Avenue as a simple two-story redbrick structure with a flat roof, symmetrical front, and shaded arcade. The second level was used as apartments and later as a doctor's office. In 1949, the structure was used as a retail store, and an addition was added in 1952. The post–World War II era brought the Western style with the upper corral, stylized sign, and horse feature. (Scottsdale Public Library.)

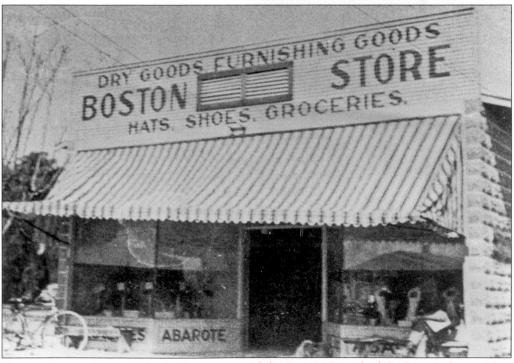

BOSTON STORE, 1920. This simple structure of the Boston Store had display windows with a canvas covering, entry doors, and metal siding above. The entire composition was symmetrical, and the front facade covered the pitched roof. Marshall and Lillian Kubelsky, aunt and uncle of comedian Jack Benny, ran the store. They handled dry goods, shoes, groceries, and eventually specialized in fabrics and clothing. (Scottsdale Historical Society.)

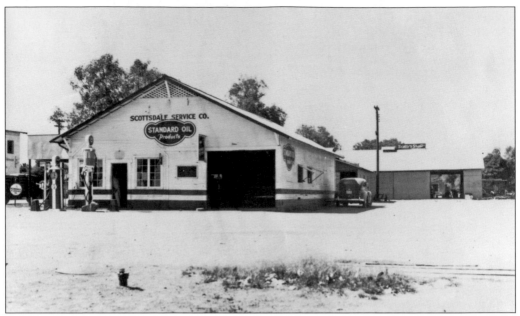

Scotty's Blacksmiths, 1930s. Scotty's Blacksmiths was located at the northeast corner of Scottsdale Road and Main Street (rear right). The Scottsdale Service Company building in front was a commanding structure with a high-pitched, strong roof form with a contrasting base color. (Scottsdale Public Library.)

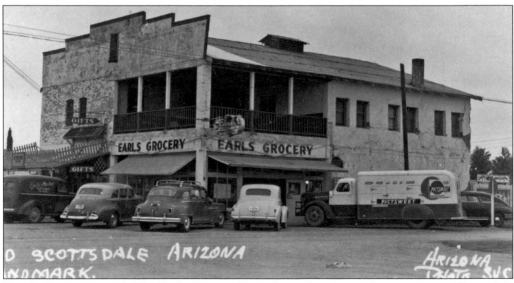

Earl's Grocery, 1935. The Earl's Grocery Store, located at the northwest corner of Scottsdale Road and Main Street, was a two-story structure with retail and residential space above. The symmetrical stepped front wall addressed the street, and the side view reveals a pitched-roof form. The store's signage was strategically placed and sized to attract customers. The upper level has a large recessed balcony, which visually erodes the corner. (Scottsdale Historical Society.)

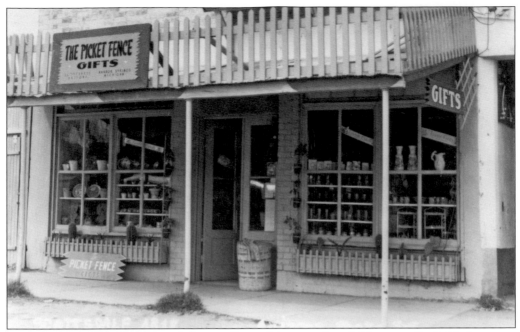

THE PICKET FENCE. The first gift shop in Scottsdale opened in 1945 next to Earl's Market, west of Scottsdale Road and Main Street. The retail shop had a roof-mounted picket fence, large display windows, entry doors, and a shade canopy, which all attracted customers. (Scottsdale Public Library.)

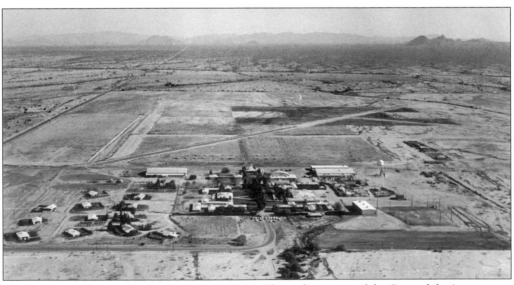

THUNDERBIRD II FIELD BUILDINGS, 1942–1944. The earliest stage of the Scottsdale Airport was the Thunderbird II Air Field designed by Millard Sheets and was where World War II pilots were trained. Airplane hangers, an air control tower, water tower, ancillary structures, and residences are seen to the lower left. A landscaped, open space with crisscrossing pathways connected the core buildings. (Scottsdale Public Library.)

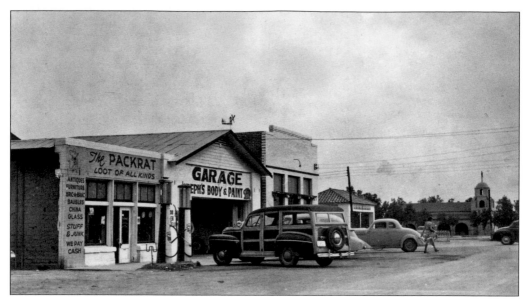

Brown Avenue, 1947. This view on Brown Avenue and north of Main Street shows J. Chew's Grocery Store to the right, which opened in 1928. The grocery store was formerly the 1923 Johnny Rose's Pool Hall and a silent film theater and later became Mexican Imports. The structure has held up extremely well with white pre-glazed brick walls. A garage is located in the middle and was once the A. F. Mahoney General Store. (Scottsdale Public Library.)

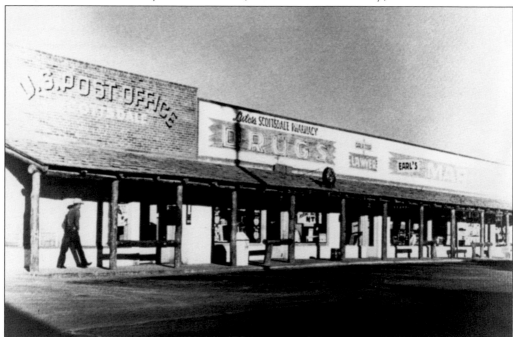

Lute's Scottsdale Pharmacy, early 1950s. Lute's Pharmacy was centered between the U.S. Post Office (left) and the new Earl's Market (right), which was just south of Main Street on Scottsdale Road. A continuous shaded arcade knits together these three downtown businesses. A Western architectural theme is found in the shade canopy of log columns, beams, and hitching posts. (Scottsdale Public Library.)

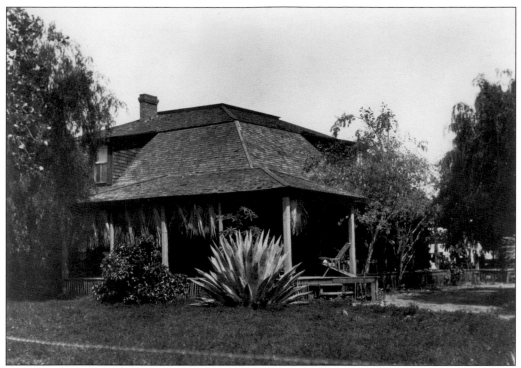

HOWARD UNDERHILL HOUSE, C. 1900. The Howard Underhill house was located at the northwest corner of Scottsdale and Indian School Roads and had a steeply pitched roof and a shaded porch. It became the Oasis Villa, which was the first guest ranch. Mature landscaping and suspended palm fronds filtered the intense sunlight and minimized glare. Wood shingles cover the roof and wall siding. (Scottsdale Public Library.)

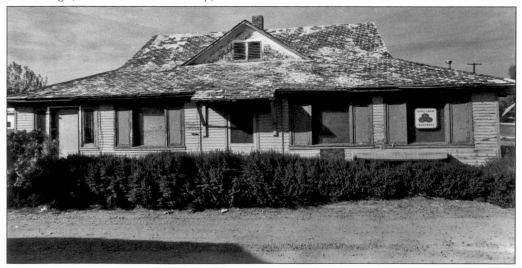

WALTHALL HOUSE, 1908. The Walthall house was located at the southwest corner of Scottsdale Road and Second Street and was a fine example of a Territorial-style farmhouse in early Arizona. This residence conveyed an inviting character with the expansive roof that cast shadows on its clapboard walls. The horizontal composition with the small "eye" vents at the gabled-roof ends enhanced the elevation, which was originally built by Henry Serviss. (Scottsdale Historical Society.)

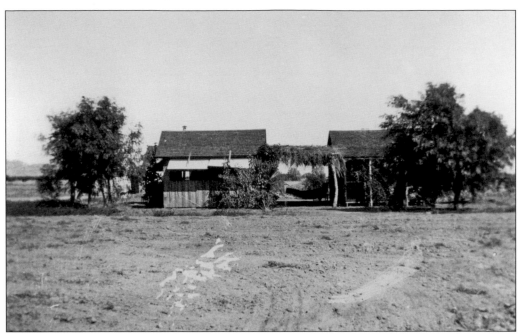

WALTER SMITH HOUSE, 1909. The Walter Smith house, a rural farming residence, was located east of Sixty-Eighth Street on Indian School Road and had two small structures connected by a brush shade ramada. The structures were framed with wood siding and pitched roofs with wood shingles. Canvas window coverings encouraged natural ventilation when open while preventing direct solar heat gain. Surrounding trees also offered important shade. (Scottsdale Public Library.)

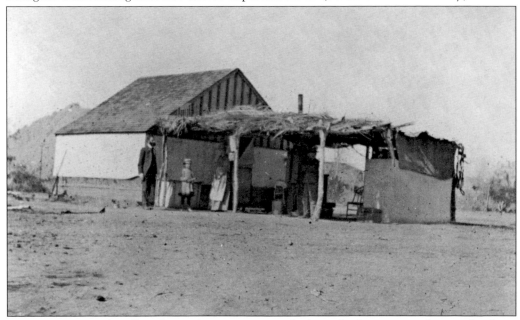

ELLIOTT HOUSE. The Elliott house farming structure had wood siding, canvas flaps in the down position, and a medium-pitched roof with wood shingles. Adjacent to the building was a large brush ramada constructed of wood posts and a thatched cover—a structure influenced by those built by nearby Native Americans. (Scottsdale Public Library.)

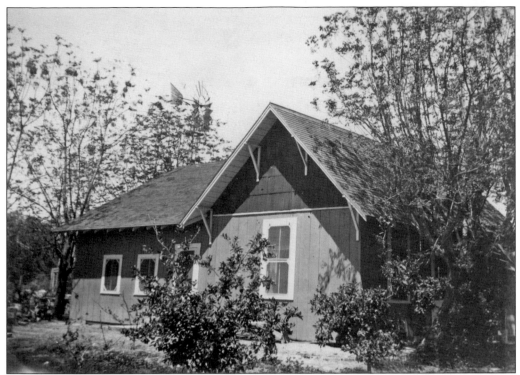

Vanderhoof House. Verner A. Vanderhoof came to the area in 1892 and found work at the F. F. Titus Ranch located south of downtown. He was tightly bound with the history of the First Baptist Church of Scottsdale. The Vanderhoof house was wood framed with a steeply pitched roof supported by brackets. Overhangs casted shade on lower walls, which cooled them down in the hot climate. Wood trim and windows articulated the exterior walls. (Scottsdale Historical Society.)

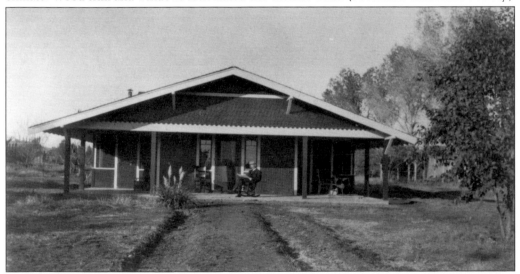

Kimsey House. W. M. Kimsey is seen on the front porch of his residence at 7120 East Indian School Road. The property was once a citrus orchard and covered most of the Fifth Avenue area. A wide, low-pitched roof form over the recessed walls and porch provided shade, while it suggested reaching out to the landscape. (Scottsdale Public Library.)

ADOBE HOUSE, C. 1950. The 1890s Blount residence experienced fire and water damage in the 1920s. School classes, a cheese factory, guest ranch, city library, and arts and crafts classes were all activities that later occurred here. The two-story structure had a floating roof over lower elements, railings, and chimneys. The walls were made of adobe and wood lintels at openings. Evaporative cooling units made the hot temperatures tolerable. (Scottsdale Historical Society.)

MARSHALL FAMILY HOUSE, 1920s. The Marshall family house was located on Indian School Road and was home to U.S. vice president Thomas Marshall. The house had a hipped roof form and dormer, which floated over a screened porch. Two fireplace chimneys provided internal heating during the winter. Light-colored trim and columns delineated the structure and defined the roof edge. Later it became the Shutters Restaurant. (Scottsdale Public Library.)

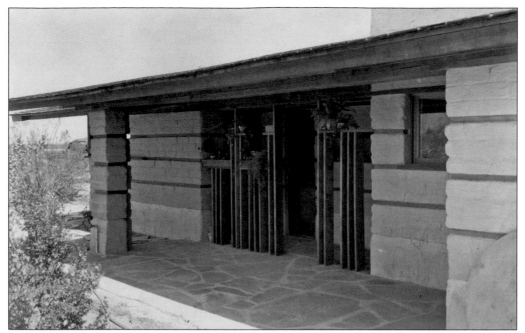

DAVID ELLIS RESIDENCE, 1941. George Ellis designed and built this small residence for his son David in the Cattletrack neighborhood. The contemporary ranch-style residence had a low-pitched roof, sheltering walls of adobe, and horizontal redwood planks. A fireplace and built-in cabinets, shelving, and seating units were integrated into this overall design. Frank Lloyd Wright, with his staff, actually toured the house explaining that this was the construction quality that he expected on his projects. (Janie Ellis.)

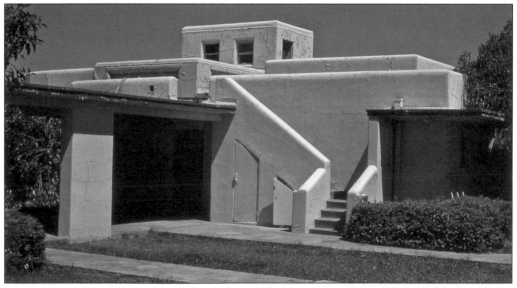

MCCORMICK RESIDENCE, 1980s. From the northwest corner of Scottsdale and Indian Bend Roads, Fowler McCormick, grandson of Cyrus McCormick, purchased 4,236 acres in Scottsdale for a winter home. He and his wife, Anne, raised Black Angus cattle and championship Arabian horses there until 1969. This 1942 sprawling residence had plastered adobe walls that stepped up to a roof deck and modern details such as the thin shade canopies. (Author's collection.)

FIRST BAPTIST CHURCH, 1920. The First Baptist Church was located at Brown Avenue and Indian School Road. The concrete-masonry structure had a wood-framed roof, gabled ends, a corner porch at the entry door, and smaller inset windows. (Scottsdale Historical Society.)

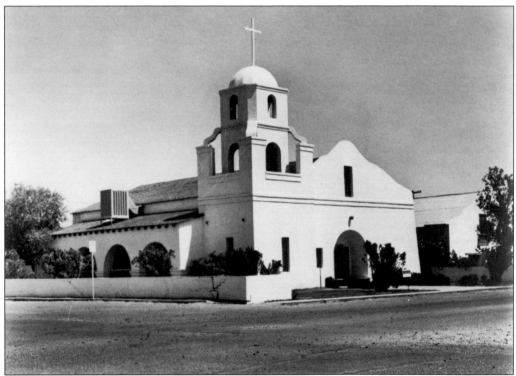

OUR LADY OF PERPETUAL HELP MISSION CHURCH, 1933. Located at 3817-21 North Brown Avenue, Our Lady of Perpetual Help Mission Church is an interpretation of the Spanish Colonial Revival style and used a rectangular plan that seated 150. It anchors the street intersection with an asymmetrical composition of a bell tower, scalloped facade, medium pitched-gable roof, and arched entry door. The walls are three adobe bricks thick and were made by future parishioners in a nearby adobe pit. Architect Robert "Bob" T. Evans provided the plans in 1927. (Scottsdale Public Library.)

Two

CREATIVE ARTS
AND TOURISM IMPACT
1930–1961

Scottsdale's climate, desert, and open spaces influenced its initial growth, and the earlier settlers, with their religious beliefs, contributed to a community of culture.

Doctors and others promoted the ideal dry winter climate found in the Southwest and the improvement of certain medical conditions such as tuberculosis, arthritis, and asthma. Those who could afford to visit or relocate to Scottsdale for the climatic benefits had the financial resources and brought an appreciation of the arts. Some sought an inspirational place that accepted personal expression including painters, craftsmen, musicians, writers, architects, and preachers.

A local artists' colony developed their arts and crafts, including Marjorie Thomas opening her own art studio. During the Depression era, there was an influx of fine artists who stayed, lived, and worked in Scottsdale, including Phillip Curtis and Lon Megargee. Art galleries were established including the 1947 Arizona Crafts Center, Buck Saunders's Art Gallery, the 1950s Stable Gallery, The Trading Post on Brown Avenue, and O'Brien's Art Emporium on Sixth Avenue. Malcolm White and Harry Nace opened the 1948 T Bar T Theater on Main Street and then the first drive-in movie theater, The Round-Up, on Thomas Road.

Architectural offerings that enriched the community included Frank Lloyd Wright's 1937 Taliesin West and Paolo Soleri's 1956 Cosanti. They each grew, evolved, and taught many lessons of how to build in this fragile desert environment.

Venues for leisure-oriented facilities and restaurant opportunities were provided, such as the Reata Pass Restaurant, the 1954 Sundown Ranch/Scottsdale Country Club and Golf Course, the 1955 Scottsdale Baseball Stadium, and the 1957 Pinnacle Peak Patio Steakhouse.

Accommodations for visitors and tourists started very early with the 1910 Graves Guest Ranch, the 1926 Jokake Inn Tea Room, and later the 1937 Kiami Lodge and the 1946 Paradise Inn. The 1950s and 1960s had a ground swell of hospitality properties including the 1955 Safari Hotel, the 1956 Hotel Valley Ho, and the 1958 Mountain Shadows Resort on Lincoln Drive, as just a few examples.

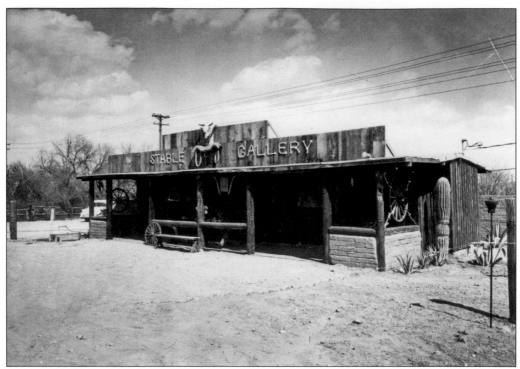

STABLE GALLERY, 1967. This original 1927 residence is located at 7610 East McDonald Drive. In 1947, it was the home of Russ Lyon Sr. and in 1950 received renovations that transformed it into Western-style architecture. This was reflected in the symmetrical facade of vertical wood planks, low adobe walls, and a full-width shaded canopy. Additional theme details are the hitching post, wagon wheels, and rope signage. (Scottsdale Historical Society.)

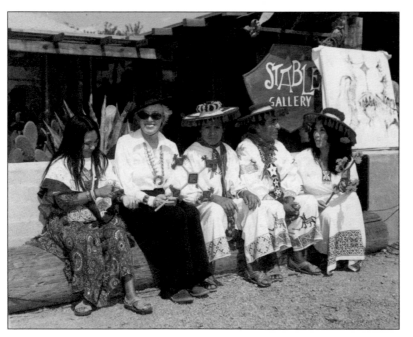

STABLE GALLERY. Avis Read (second from left) arrived with her family in 1950. She was a fine artist and featured various cultural groups' fine art and crafts in her Stable Gallery, which is behind them. Their work was exhibited and sold through many Scottsdale-based art galleries then and until today. (Scottsdale Historical Society.)

GEORGE ELLIS, 1930S. An engineer, farmer, and contractor, George Ellis moved to Scottsdale in 1935, married Rachael Murdock, and had a passion for architecture. Starting in 1937, he built a dozen custom homes, including the Upton and Paulson residences, and continued for decades. He developed appropriate desert architecture with low horizontal compositions, outdoor connections, and local found materials such as adobe, railroad ties, and metal siding. (Janie Ellis.)

GEORGE ELLIS DESERT STUDIO, 1936. The George Ellis Desert Studio is located at 105 North Cattletrack Road among a mesquite tree bosque. It was the first in a series of structures and housed his personal studio. It was made of Verde River pipeline redwood, which accounts for the band-line marks. The roof is low pitched and wood framed with overhangs and gable ends. (Janie Ellis.)

CATTLETRACK COMPLEX, 1937–1940S. This 8.4-acre complex at 105 North Cattletrack Road includes one main building and eight ancillary structures: the 1937 George L. Ellis house, the 1940s expansion, the 1938 Kuffner residence, and a relocated 1960s Blaine Drake residence. The complex is characterized by the random placement and eclectic mix of residences and artist studios. It also captures an authentic rural character of living, working, and creating in early Scottsdale. It was added to the National Register of Historic Places in 1999. (Scottsdale Public Library.)

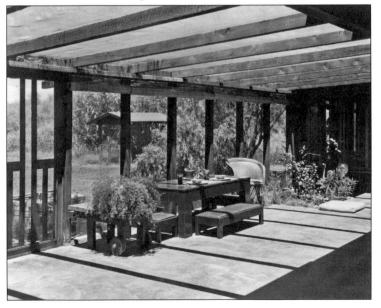

CATTLETRACK PATIO, 1936. A seamless connection exists with the outdoors at the Cattletrack complex by a series of transitional and ever changing patio spaces. Some are defined by a wood framework with shade screening, which provided diffused light and cast strong shadows. The compound, designed and contracted by George Ellis, is known for capturing a dynamic relationship with the natural landscape and sunlight. (Janie Ellis.)

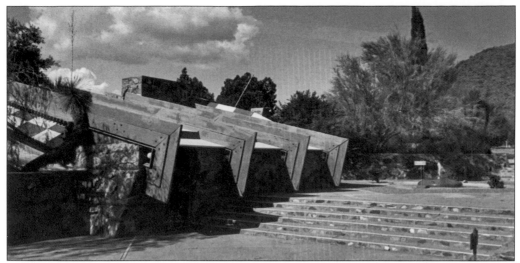

TALIESEN WEST. From 1937 to 1959, the internationally recognized School of Architecture at 12621 North Frank Lloyd Wright Boulevard was an experiment by architect Frank Lloyd Wright in how to appropriately build in the upper Sonoran Desert. Natural ordering systems and angular forms were not unlike the nearby McDowell Mountains. Materials of concrete and native stone were set in the desert masonry walls to visually root the faceted walls and overhangs to the site, which is part of the National Register of Historic Places. (Scottsdale Historical Society.)

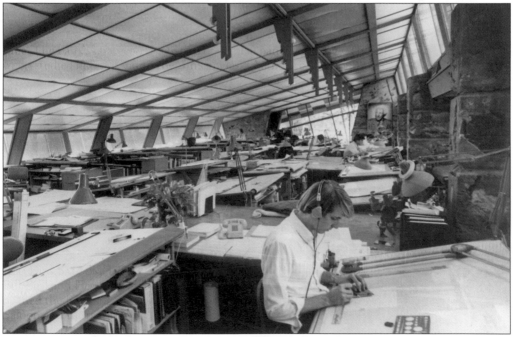

TALIESEN WEST DRAFTING ROOM. The Taliesen West interior drafting room designed by architect Frank Lloyd Wright had redwood frames and was bathed in diffused lighting from canvas panels. The panels proved technologically challenging with the summer heat gain and leaks, which then led to other options including fiberglass. A dynamic interrelationship existed between multiple sensitively sited structures, the in-between spaces, interiors, and desert surroundings. (Scottsdale Historical Society.)

SEGNER CRAFT VILLAGE, C. 1950s–1960s. Wes Segner designed his self-titled Segner Craft Village that was located at North Miller Road and Fourth Avenue. The village housed craftsman such as silversmith Wes Segner, artist William Schimmel, glaziers Joe Lincoln and Jos Maas, and calligrapher/ photographer Leonard Yuschik. The structures were contemporary and horizontally composed with low-pitched roofs, upper windows, and evaporative cooling. (Scottsdale Historical Society.)

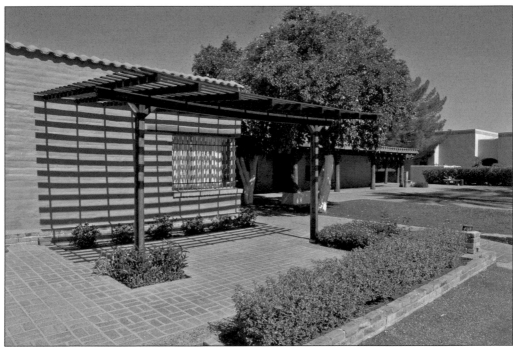

LOUISE LINCOLN KERR CULTURAL CENTER. At 6110 North Scottsdale Road, there was a 1943 one-story house in the Spanish Colonial style with adobe bricks made and dried by Mexican artisans. A staircase provides access to the roof, and entry doors were hand carved by Tucson artist Charles W. Bolsius, a friend of Louise Lincoln Kerr. In 1959, a studio that seats 210 was added, and in 1969, architect Fred Fleenor constructed another addition. The cultural center serves as a special place for musicians and artists to work and perform. (Author's collection.)

CRAFTSMAN COURT, 1955.
Architect T. S. Montgomery
designed Craftsman Court,
located at 7121–7141 East Fifth
Avenue, as a space where the
public could watch featured artists
create. Some of the artists were
Leona Caldwell with fabrics,
goldsmith Alexander Kowal,
Lloyd Kiva New leather goods,
and perfumer Erne. Seven
modern buildings revolve around
a patio with a water feature and
shade trees. Low-pitched roofs,
masonry walls, display windows,
and shaded passageways captured
an inviting pedestrian-oriented
scale. (Scottsdale Public Library.)

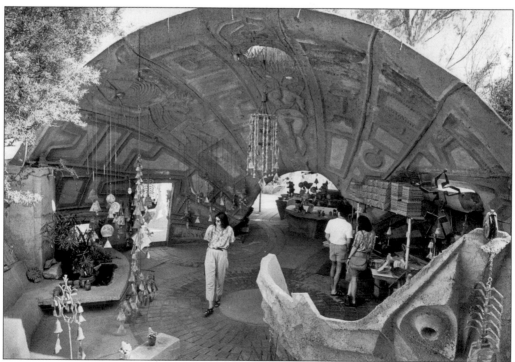

COSANTI. Architect Paolo Soleri initiated Cosanti in 1956 at 6433 East Doubletree Road and was
a visionary who explored his concept of "arcology," where architecture and ecology are integrated.
He created sculptural structures by mounding earth, placing forms, casting concrete shells, and
then excavating from underneath, thereby revealing the cast forms. Building orientation provided
shade and encouraged natural ventilation. Construction was funded by the sale of his world-famous
cast bronze wind-bells. (Scottsdale Historical Society.)

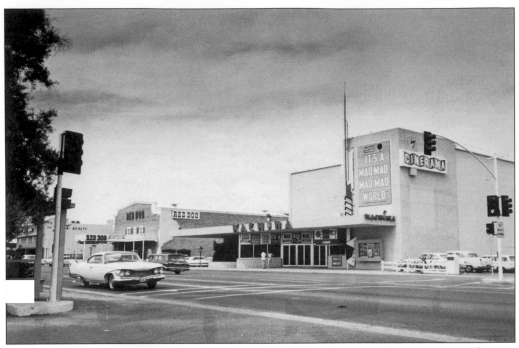

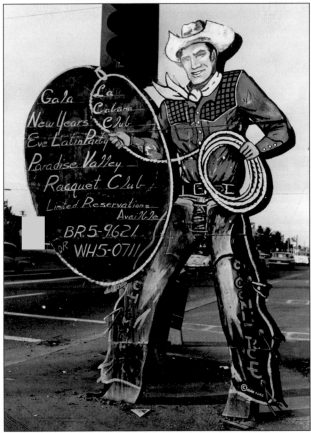

KACHINA CINEMA, 1960. This Kachina Cinema in Scottsdale offered another cultural venue at the northeast corner of Scottsdale Road and Fifth Avenue. The cinerama wide screen, comfortable seating, and blockbuster films were quite popular. The exterior theme featured a Kachina doll in the signage and an oversized arrow that extended beyond the roof. (Scottsdale Historical Society.)

COWBOY SIGN, 1952. The Scottsdale Chamber of Commerce erected the wooden sign at the northeast corner of Scottsdale Road and Main Street. The sign showed a cowboy with a lariat, which was eventually reconstructed to tin in the late 1960s. Over the years, it has become a recognizable feature in downtown Scottsdale. (Scottsdale Historical Society.)

SCOTTSDALE COUNTRY CLUB AND GOLF COURSE, 1960s. This 1953 golf course, at the northwest corner of Hayden Road and Shea Boulevard, was redesigned in the 1980s by Arnold Palmer. One-story structures with pitched roofs and gable ends housed the golf clubhouse and rental units. A series of Scottsdale area golf courses have been developed over the past 100 years and offer a recreational activity for visitors and residents. (Scottsdale Historical Society.)

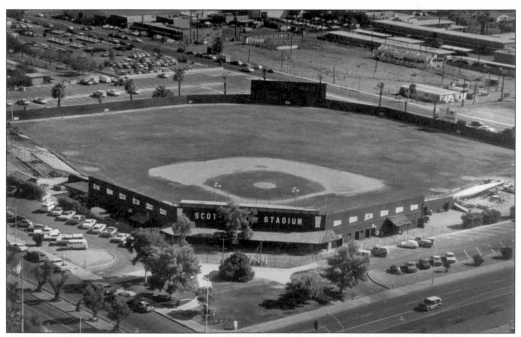

BASEBALL STADIUM, 1955. This baseball stadium was located at 7408 East Osborn Road and used a Western Revival style of board-and-batten siding, a pitched entry canopy, and baseball graphics. A wall faced the street but once a fan stepped inside, a sea of green grass and viewing stands captured the magic of baseball. The Baltimore Orioles were the first professional baseball team to train there in spring 1956 and would be followed by others, including the San Francisco Giants. (Scottsdale Historical Society.)

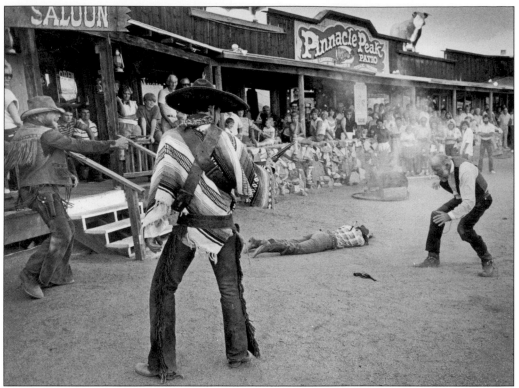

PINNACLE PEAK PATIO STEAKHOUSE. Located at 10426 East Jomax Road, the Pinnacle Peak Patio Steakhouse captured the Wild West with its Western Revival–style facades, signage, and hitching posts in 1957. They also simulated gunfights as shown here with Steve Barnes (left) and Tom Coons (wearing Mexican hat) as they shoot at Hank Guyor, who was the head of the "Arizona Gunslingers." (Scottsdale Historical Society.)

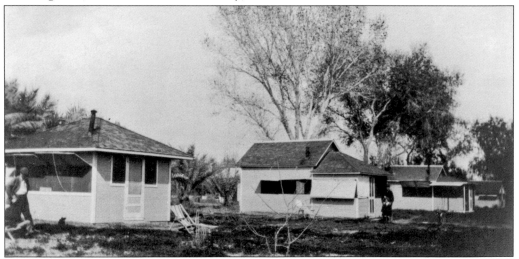

GRAVES GUEST RANCH, C. 1910. The Graves Guest Ranch was originally the Underhill home for tourists, then the Oasis Villa catering to both vacationers and as a tuberculosis recovery center. Patients stayed in small wood-framed cottages with canvas flaps, which provided fresh clean air, natural ventilation, and filtered sunlight. (Scottsdale Historical Society.)

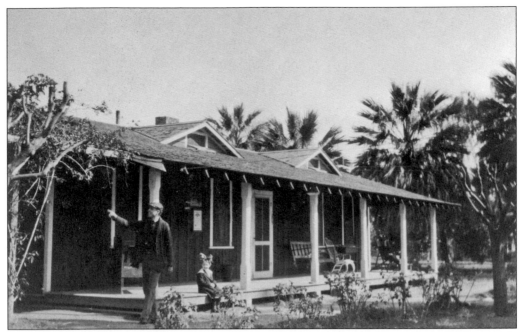

Graves Guest Ranch, 1930. The Graves Guest Ranch at the northwest corner of Scottsdale Road and Indian School Road had a low-pitched roof with hipped dormers over a shade canopy with wood columns and a raised deck. It was constructed of wood flooring, board-and-batten siding, roof of wood shingles, and a chimney. Its character captured a casual ranch-style architecture. (Scottsdale Historical Society.)

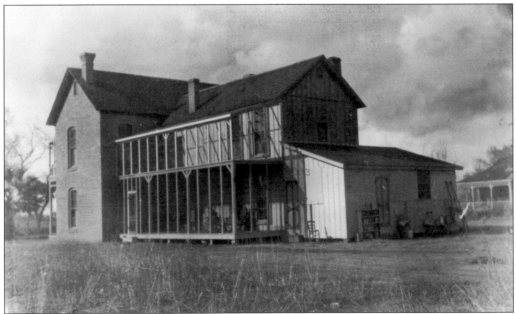

Elliot Sanitarium, 1930s. The two-story, *L*-shaped plan for the Elliot Sanitarium created solid building volume with wraparound screened porches at both levels. A medium-pitched roof form and a series of fireplace chimneys capped the composition. The visual dialogue between the solid volumes and the open framed volume creates an appealing balance. (Scottsdale Public Library.)

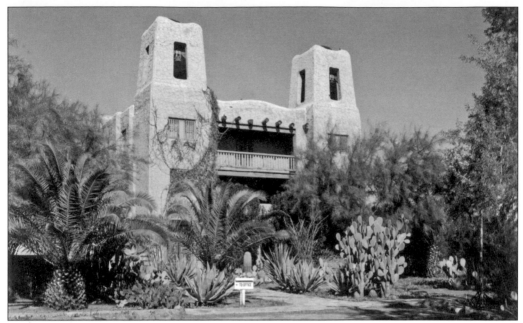

JOKAKE INN TOWERS, 1936. Twin towers flank the resort entry, which is located at 6000 East Camelback Road. The architectural character was Pueblo Revival with plastered adobe walls, small windows, and exposed roof beams. *Jokake* is actually a Hopi word for "mud house" and is appropriate given the style. In 1924, architect Robert T. Evans helped revive the use of adobe, and he designed innumerable adobe structures in the area. (Scottsdale Historical Society.)

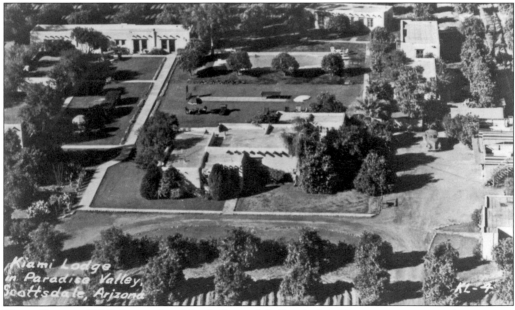

KIAMI LODGE, 1937. Located on North Scottsdale Road, this 10-acre resort was within a citrus grove and made up of four cottages, pathways, and patios that took advantage of the bright sunlight. Recreational amenities included horseback riding, tennis, and golf. Until the 1950s, there was a track located on the grounds to watch thoroughbred horse races. The architectural style was described as "Indian," and it influenced the interior decorations and furniture. (Scottsdale Historical Society.)

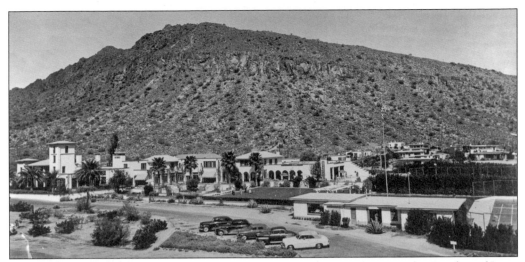

PARADISE INN, 1946. The Paradise Inn was located at Camelback and Invergordon Roads, and Jessie Benton Evans built its original structures for her home. Then her son, architect Robert T. Evans, later owned and enlarged it. This sprawling resort was composed of multilevel structures that adapted to the foothills' natural topography. Pitched clay-tile roofs, plastered walls, small windows, arched doorways, and landscaping were all carefully choreographed. (Scottsdale Historical Society.)

HOTEL VALLEY HO, 1956. The Hotel Valley Ho, located at 6850 East Main Street, underwent an expansion in 1958. This was one of the first resorts that capitalized on the post–World War II movement of employees to the Valley. The original structure, designed by architectural firm Edward L. Varney Associates with project architect Reginald Sydnor, AIA, was composed of brick walls, innovative concrete-lift slabs, balustrades, and custom railings. (Scottsdale Public Library.)

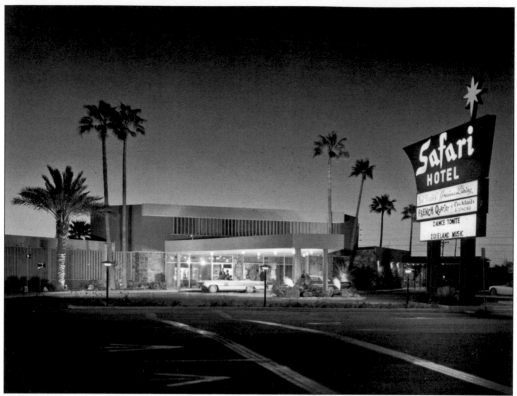

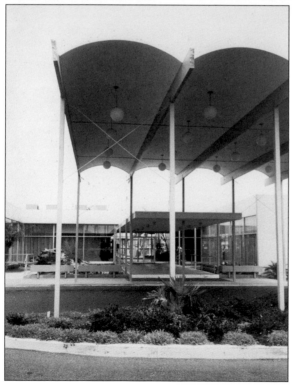

SAFARI HOTEL, 1955. Ernie Uhlmann and Bill Ritter developed the Las Vegas–influenced Safari Hotel at 4611 North Scottsdale Road. It housed the popular French Quarter that booked famous nightclub acts and was a major valley attraction. Modern design by architect Alfred Newman Beadle included exterior plaster walls with a light purple color to simulate the McDowell Mountain shadows. (Scottsdale Historical Society.)

EXECUTIVE HOUSE ARIZONIAN, 1961. The southeast corner of Scottsdale and Chaparral Roads once hosted The Scottsdale National Indian Arts Exhibition, organized by Paul Huldermann and Lloyd Kiva New, which brought in entrants from throughout the United States. The architecture had very contemporary lines with slender wood columns, a thin vault roof, and full-height glazing. (Scottsdale Historical Society.)

Three

POST–WORLD WAR II
DEVELOPMENT
1947–1973

In 1947, the Scottsdale Chamber of Commerce urged Scottsdale businesses to construct and remodel buildings with only a Hollywood version of the Western Revival style, and in 1953, the town council appointed an architectural board to ensure adherence to this theme. The preoccupation with all things Western was reflected in the television programs, movies, and novels of the time.

Scottsdale was incorporated as a town in 1951, after many years of study and public hearings. Given the visual improvements, community activities, and resort apartments for seasonal residents, the population grew from 10,000 in 1960 to 72,000 in 1972 and covered 70 square miles. To accommodate growth, 103 subdivisions of single-family, ranch-style homes were constructed from 1943 to 1973.

Scottsdale became progressive at upgrading the community and pursuing a more sophisticated architecture with the help of many new ordinances and policies. A few examples include the 1954 Sign Ordinance and the 1962 Prohibition of Billboards that aesthetically transformed this new town. In 1964, the Scottsdale Town Enrichment Program (STEP) was formed and recommended many civic infrastructure improvements, including the creation of a greenbelt rather than the concrete box channel suggested by the Army Corps of Engineers for flood control. Starting in 1971, the birth of Indian Bend Wash Greenbelt improvements became a positive open-space amenity. In 1965, the City of Scottsdale initiated a beautification program by planting more than 400 palm trees, and in 1967, Eldorado Park became Scottsdale's first major park. Focusing on the spaces between buildings, a landscape ordinance that encouraged the use of desert plants was passed in the early 1970s. The city also formed the Design Review Board during the 1970s that helped guide appropriate architecture for this desert setting.

During this period, equine-related facilities such as ranches and residential horse properties evolved in northern Scottsdale. Events also focused on Western, Hispanic, and Native American traditions. Complementing these interests was a more trendy and fashion-conscious market that was gaining a national reputation and attracting tourists and celebrities.

Architectural styles were varied and included Old West Eclectic, Victorian Revival, and contemporary. The post–World War II era brought about phenomenal growth, a prosperous economy, innovative business, political leadership, and an involved citizenry.

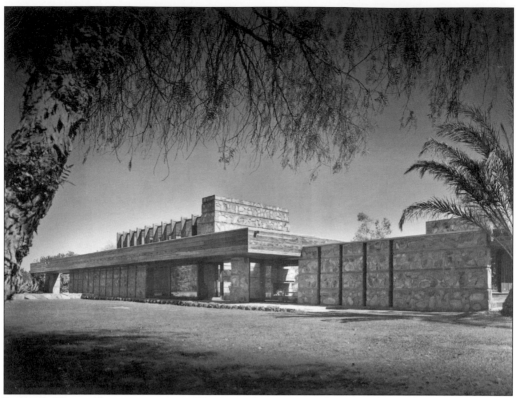

LOUIS C. UPTON RESIDENCE, 1949. The Louis C. Upton residence was located on a 21-acre citrus orchard and alfalfa fields in the current downtown. The home was constructed in four units of natural stone, redwood framing, and glass. The horizontal composition for the main structure and the three outdoor rooms were capped with a screened-roof garden. In time, the home—designed by architectural firm Schweikher and Elting with Paul Schweikher, FAIA, and contractor George Ellis—became an elite speakeasy and private club grill. (Julius Shulman, Will Bruder + Partners, Ltd.)

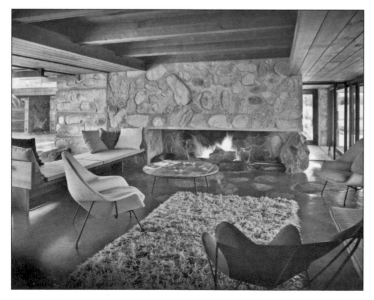

LOUIS C. UPTON RESIDENCE INTERIOR, 1949. Stone floors, stone fireplaces, horizontal wood shelves, and glass slots at the masonry walls conveyed a crafted desert home designed by Schweikher and Elting with Paul Schweikher, FAIA. Beyond the building's physical materials, the floor plan and character integrated the use of a reflecting water pool, fire, and fragrance from flowers. (Julius Shulman, Will Bruder + Partners, Ltd.)

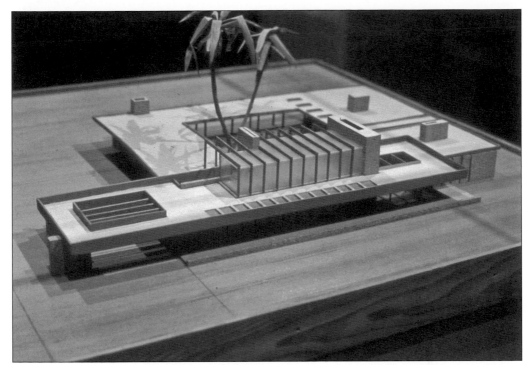

LOUIS C. UPTON RESIDENCE MODEL, 1949. The original model of the Louis C. Upton residence is in the New York City Museum of Modern Art's permanent collection, acknowledging this architectural masterpiece. Despite the quality of this home, it was mistakenly demolished in the early 1970s. Architect Paul Schweikher, FAIA, of Schweikher and Elting designed the residence before leaving the firm in 1953 to become chairman of the School of Architecture at Yale University. (Author's collection.)

MAURY RESIDENCE, 1948. Located on a 127-acre desert parcel near Pinnacle Peak, the Maury residence was designed and built by George Ellis. Known as Crescent Moon, this contemporary, low-scaled residence and three guest cottages were constructed of 18-inch adobe, redwood framing, glass, and flagstone and colored concrete floors. (Pedro E. Guerrero, Janie Ellis.)

VILLAGE GROVE 1–6, 1957. Located at the southwest corner of Oak and Sixty-Eighth Streets, Village Grove, constructed by Allied Construction Company, is one of the finest preserved post–World War II residential subdivisions. These mass-produced ranch-style homes were constructed of masonry, low-pitched roofs, diamond-patterned windows, open carports, and entry porches. Media evidence noted that Scottsdale gained a national reputation for such construction methods and marketing strategies in affordable homes. (City of Scottsdale.)

TOWN AND COUNTRY SUBDIVISION, 1958. The Town and Country subdivision is located at the southwest corner of Seventy-Fourth and Oak Streets. The front elevations have a symmetrical and low-pitched roof that floated over an open carport and high glass. Slightly varied fronts explored different wall materials including this handcrafted brick. In the 1950s and 1960s, architect Ralph Haver and Associates completed over a dozen residential subdivisions in the Phoenix area, and this subdivision is one of the best preserved. Fred E. "Woody" Woodworth was the builder. (City of Scottsdale.)

VILLA MONTEREY CONDOMINIUMS. The 1960s Villa Monterey Condominiums development is located at the Miller and Chaparral Roads area and was constructed by Butler Homes in nine phases. Elevations were composed of attached one- and two-story units in a simplified Territorial Revival style, which animated the overall character. Clay-tile roofs, ornamental iron, and plastered light-colored walls provided visual continuity. (Author's collection.)

McCORMICK RANCH. The 1971 master-planned community of McCormick Ranch was one of the first in Arizona and was developed by Kaiser Aetna. Composed of single-family subdivisions, patio homes, condominiums, apartments, and commercial buildings, the community's character was predominantly Spanish Colonial/Mediterranean Revival with off-white plastered walls, clay-tile roofs, and decorative columns. Open spaces are pleasant with golf courses and pedestrian pathways that are separated from vehicles. Lakes and mature landscaping help provide cooler temperatures during the summer. (Author's collection.)

CAMELBACK PARK ESTATES. At the northwest corner of Scottsdale and Chaparral Roads, Camelback Park Estates was the first single-family residential subdivision in the early 1950s, which was built by Jim Paul who later developed Mountain Shadows Resort and Rawhide. The character is modern with low-pitched roofs, painted masonry walls, and rectangular multipaned windows. (Author's Collection.)

ADOBE APARTMENTS. The 1953 Adobe Apartments consists of a U-shaped plan with 3 one-story buildings situated around a courtyard at 7037–7041 East First Avenue. The structures are constructed of adobe, wood-framed roofs with shingles, and small-paned windows. The property is listed on the Scottsdale Historic Register. (City of Scottsdale.)

50

JACARANDA APARTMENTS. This post–World War II, 1958, two-story structure with a courtyard plan is located at 6824 East Second Street. The Jacaranda Apartments had a flamboyant piece with a cantilevered roof and a round opening for a palm tree, which added to its curb appeal and attracted potential renters. (Author's collection.)

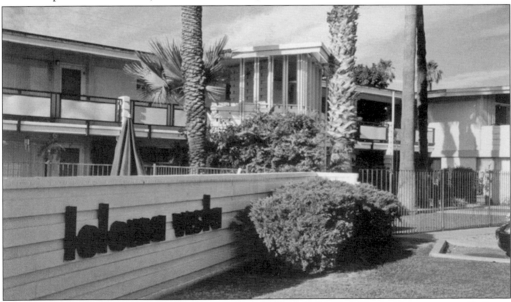

LOLOMA VISTA APARTMENTS, 1958. Located at 6928 East Second Street, the two-story Loloma Vista Apartments complex overlooks a swimming pool defined by masonry walls. The upper walls consist of masonry, crafted-wood detailing, and low-pitched roofs, and the architectural character is reminiscent of the craftsman revival style. (City of Scottsdale.)

CASA GRANADA EAST. The 1960s Casa Granada East townhomes are located at the southeast corner of Miller Road and Montecito Avenue. These Hallcraft-built, multifamily housing units are among many examples of the popular Spanish Colonial Revival style. Character is conveyed with plastered walls, arched openings, lintel beams, flower boxes, and clay-tile canopies. Some individuality is achieved with contrasting materials. (Author's collection.)

LOS CUATROS APARTMENTS. Located at the northwest corner of Sixty-Ninth and Second Streets, the 1966 two-story Los Cuatros Apartments complex mitigated the massing with angular walls to create strong shadows, entry canopies, and smaller windows with louvered shades. A swimming pool within an oasis-like courtyard became a focal element. The architect was Bennie M. Gonzales Associates, Inc., who was responsible for numerous multifamily residential projects in the area. (Author's collection.)

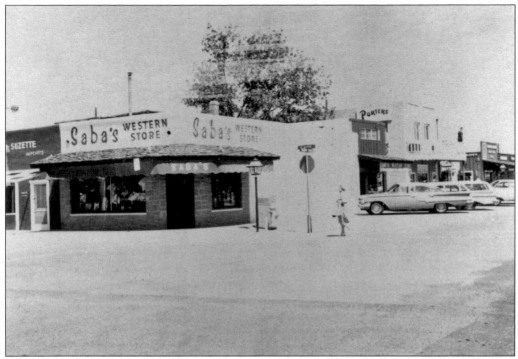

SABA'S WESTERN STORE, 1947. Originally the 1920s Sterling Drug Store, Saba's Western Store was built at 7254 East Main Street and is constructed of masonry walls, an entry facing the intersection, large display windows, a cantilevered shade canopy, and signage. The store is one of the properties designated on the Scottsdale Historic Register. (Scottsdale Historical Society.)

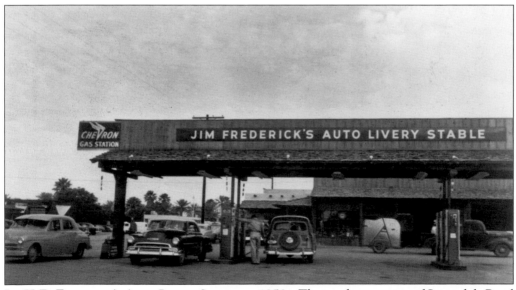

JIM V. D. FREDERICK'S AUTO LIVERY STABLE, C. 1950s. The northeast corner of Scottsdale Road and Main Street was the location of this Western Revival architectural style with board-and-batten walls, roof wood framing, wood shingles, and business sign. (Scottsdale Public Library.)

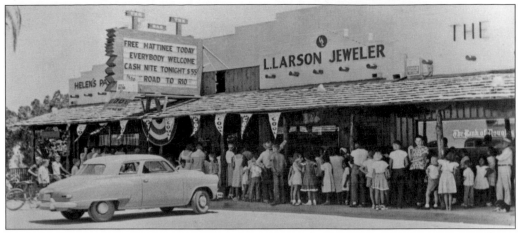

T Bar T Theater, 1948. The T Bar T Theater was located on East Main Street and was developed by former mayor Malcolm White and Harry Nace. The Western Revival architectural style provided a continuously shaded arcade that was framed with wood beams and columns. The vertical facade and a marquee of simulated board panels are both Western references. (Scottsdale Historical Society.)

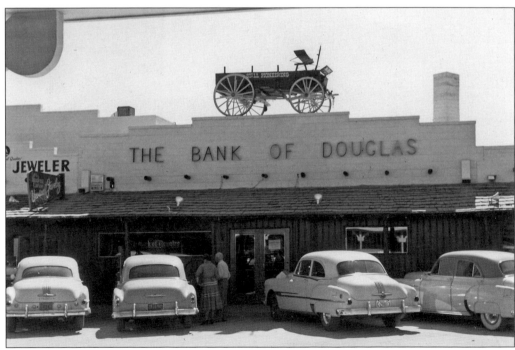

The Bank of Douglas, early 1950s. This Western style of The Bank of Douglas was achieved with a shaded arcade of wood columns, framing, and shingles and board-and-batten lower walls. The stepped profile of the facade, cornice trim, and wagon feature completed the desired nostalgic character. (Scottsdale Historical Society.)

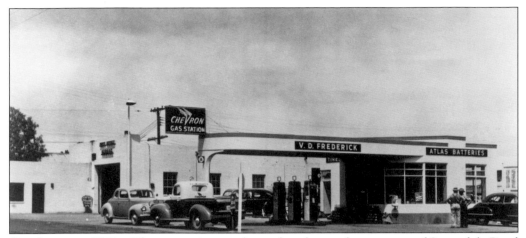

GAS STATION, 1950s. The gas station was located at the northeast corner of Scottsdale Road and Second Street. The structure had a rare art deco architectural character with a horizontal streamlined building form, floating drive-thru canopy, curved corner windows, and banding. (Scottsdale Public Library.)

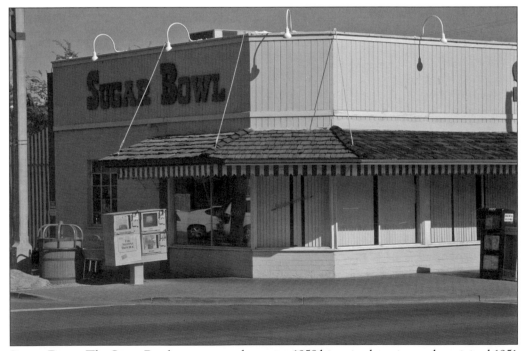

SUGAR BOWL. The Sugar Bowl structure underwent a 1958 historic alteration to the original 1951 Western Auto Service at 3933–4005 North Scottsdale Road. The Western architectural theme with painted board-and-batten, shaded canopy, Western-style sign letters, and exterior character that carried throughout the interiors was very convincing. (Author's collection.)

RANCH HOUSE SHOPS, 1950. Location of the first Goldwater's Desert Fashions Store is at the northeast corner of Scottsdale Road and First Avenue. This shopping complex with ranch architectural style was achieved with horizontal building forms, a low-pitched roof, recessed large windows, and wood rails defining an open space. (Photography by Karl, Scottsdale Historical Society.)

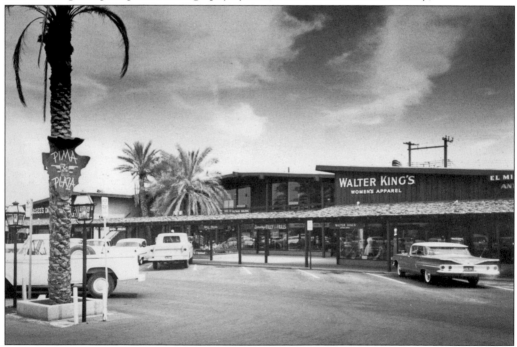

PIMA PLAZA, 1953. The Pima Plaza shopping complex is located at 7221–7235 East First Avenue and shown here are McGee's, Filly Frills, and Walter King's Women's Apparel. The two-story structure and one-story wings all focus on a courtyard. An open, covered walkway gives visual access and depth to the courtyard beyond. This contemporary interpretation of the Western style, a low-pitched roof and symmetrical composition with board-and-batten siding, was designed by Ralph Haver Architect. (Scottsdale Historical Society.)

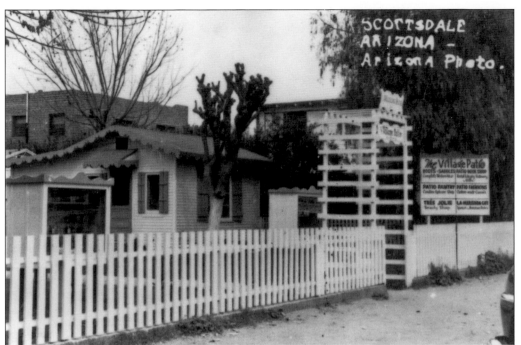

THE VILLAGE PATIO. This late 1940s downtown shopping area was a cluster of retail shops. Character addressed the street with a low picket fence, entry wood trellis, small cottages with scalloped roof fascia, clapboard siding, and small window shutters. (Scottsdale Public Library.)

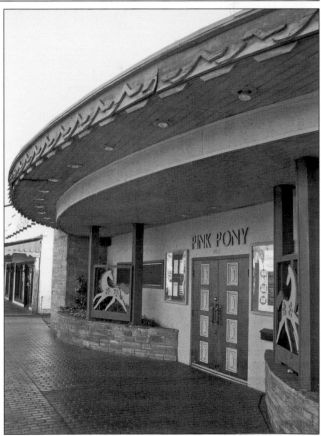

PINK PONY RESTAURANT, 1954. The Pink Pony Restaurant moved to 3831 North Scottsdale Road and underwent a 1970 historic alteration. The unique curved elevation, recessed doors flanked by a pair of raised flagstone planters and pony panels, stepped overhang, and patterned fascia attracted customers. (Scottsdale Public Library.)

LULU BELLE'S RESTAURANT. Lulu Belle's restaurant and bar remodeling to the left was located at 7212 East Main Street starting in 1954. The Gay Nineties of the Old West style was conveyed with striped board-and-batten siding, shaded walkways with wood columns topped by brackets and animated graphics and signs. (Scottsdale Historical Society.)

FIFTH AVENUE SHOPS, 1955–1965. A series of one-story retail shops evolved at Fifth Avenue and west of Scottsdale Road. A specialty retail district is unique in the Phoenix area as it had curvilinear streets and continuously shaded arcades that adapted to the Arizona Canal. This planning notion created a series of pedestrian-scaled spaces that are pleasant and make people want to turn the next corner. (Scottsdale Historical Society.)

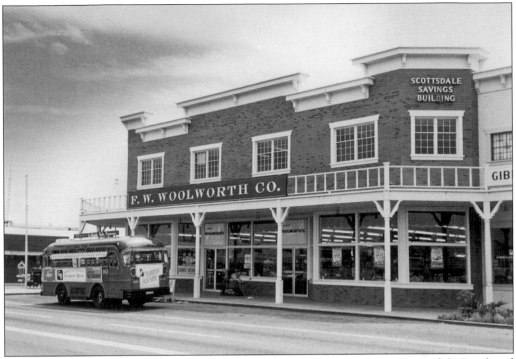

F. W. Woolworth Company, 1958. Located at the northwest corner of Scottsdale Road and Main Street, the two-story F. W. Woolworth Company store had retail on the first level and offices above. The Western Revival style is achieved with the brick facade, white window frames, covered walkway with braced wood columns, and balustrade above. The front had a stepping and projecting cornice trim, which softens the building's upper edge. (Scottsdale Historical Society.)

Triangle Building, 1962. Located at 7122 East Indian School Road is a two-story structure with retail uses at the first level and offices above. The modern style designed by Ralph Haver and Associates, Inc. was achieved through a symmetrical, low-pitched, and projecting roof with details such as wood columns, exposed beam-ends, and an open balcony. Full-height front glazing provided an inviting transparency to the street and displayed sale items. (Photos by Wes, Scottsdale Historical Society.)

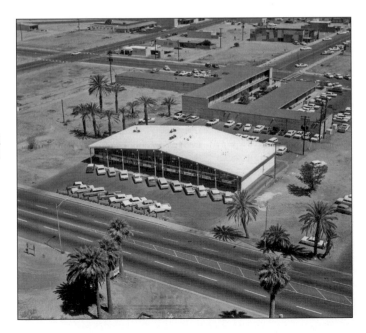

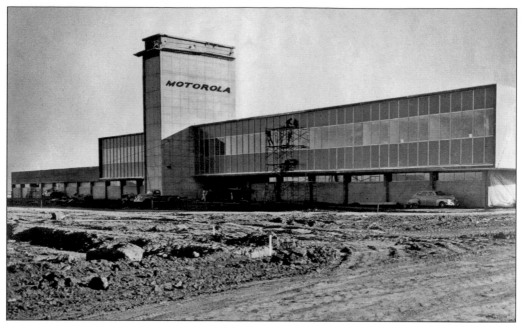

MOTOROLA GOVERNMENT ELECTRONICS, 1957. This two-story, 173,000-square-foot Motorola Government Electronics plant was under construction on a 160-acre parcel at 8201 East McDowell Road. It is composed of a central tower that doubled as an antenna test station; an upper piece of aluminum framing, glass; and first level solid walls with high windows. There were 3,500 employees who worked in the first phase designed by Edward L. Varney Associates with Reginald Sydnor, AIA, as design architect. (Scottsdale Historical Society.)

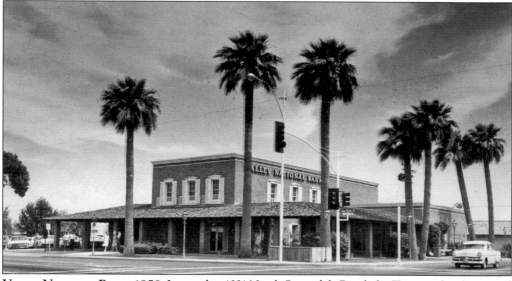

VALLEY NATIONAL BANK, 1958. Located at 4031 North Scottsdale Road, the Territorial architectural character of the Valley National Bank was provided with a brick structure and shaded walkway that wrapped around the street frontages. The walkway is constructed of brick columns, wood framing, and a shingled canopy. The upper walls provide windows with shutters and a cornice. The architectural firm that designed the building was Weaver and Drover Architects. (Scottsdale Historical Society.)

MESSINGER MORTUARY AND CHAPEL, 1958. The addition to the Messinger Mortuary is located at 7601 East Indian School Road and includes a 6,700-square-foot chapel and waiting area. Designed by architectural firm Guirey and Associates with assistant Murray Harris, the chapel is constructed of masonry, glass, wood framing, wide halls, and a shaded north entry. The entry is supported by steel tree-form columns that were fitted with French stained glass. (Paul Messinger.)

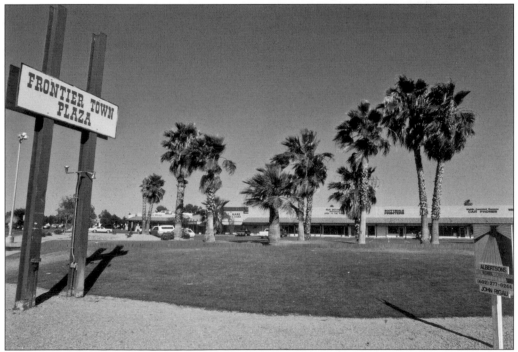

FRONTIER TOWN PLAZA, 1959. Located at the southwest corner of Scottsdale and McDowell Roads, the Frontier Town Plaza suburban shopping center accommodated smaller retail stores. It is connected with a continuously covered arcade that was supported by columns with a pitched canopy. Street building setbacks are generous as convenient parking is provided in front. It later became the Papago Plaza shopping center. (Scottsdale Public Library.)

Papago Lanes. The 1960 Papago Lanes bowling alley and restaurant is located at the northwest corner of Scottsdale Road and Palm Lane. The structure was innovative with masonry walls supporting a series of pretensioned thin shell concrete vaults with projecting ends and exposed stone walls. The entry was identified by tall concrete masts with signage. Architect Donald T. Van Ess worked with Boduroff and Meheen Engineers; Owner as Guido Orlandi and Associates; and Gilbert and Dolan Contractors to complete the project. (Author's collection.)

Scottsdale Fashion Square, 1960s. The *L*-shaped Lenart Building at left was designed by Edward L. Varney Associates and is flanked above and below by branch banks. The 1961 Goldwater's Store in the center was an anchor store, and the A. J. Bayless grocery store is at right. The original structure was built as an open-air mall with stores on each side. (Scottsdale Historical Society.)

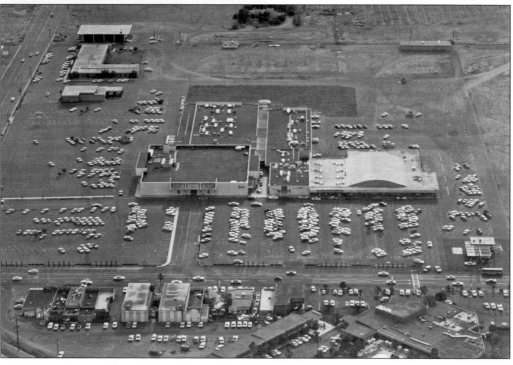

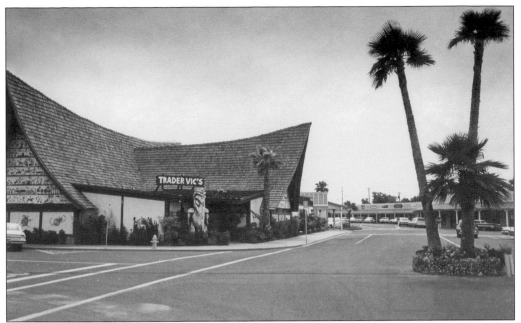

Trader Vic's Restaurant, 1962. Trader Vic's Restaurant was located at the southwest corner of Fifth Avenue and Craftsman Court and was done with a Polynesian-themed character. Features included the swooping curved and shingled roof forms, extensive graphics at the gabled ends, a hand-carved wood sculpture, and tropical landscaping. The theme carried into the interior with rich textures and colors and dimmed lighting. (Scottsdale Historical Society.)

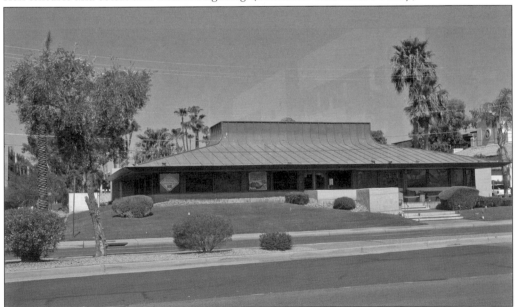

Coco's Restaurant. The 1966 Coco's Restaurant designed by architect Tom Wells is located at 4700 North Scottsdale Road. It is a refreshing reinterpretation of desert architecture with the use of earth berms for the insulation value, extensive cantilevered roof with a very thin profile, and deeply recessed horizontal glass. Interiors are intimately scaled and used natural finishes such as wood trim and cork ceilings. (Author's collection.)

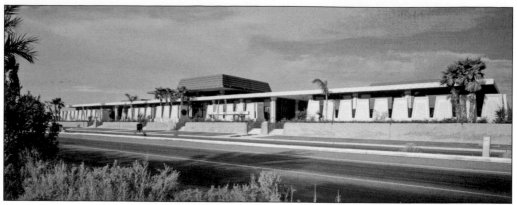

VALLEY NATIONAL BANK, 1967. At 4821 North Scottsdale Road there was a large Valley National Bank branch and other retail stores. The architectural character was modern with a raised concrete plinth, battered concrete screen panels, and patterned fascia. A series of breezeways and a pleasant landscaped patio connected the buildings. The architectural firm was Weaver and Drover with Frank Henry and Alden Barsted. (Neil Koppes, Koppes Photography, DWL Architects.)

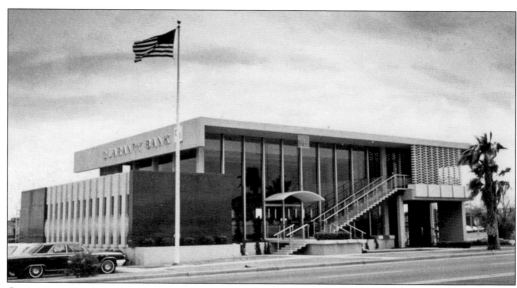

GUARANTY BANK, 1968. Guaranty Bank was located at 7111 East Camelback Road and had a two-story glazed volume designed by architect John Schotanus, AIA. The street elevation was very open, inviting, and had a strong presence with a framed-glass front that was protected with side panels and custom screens. The entry was carefully choreographed with a suspended vault panel, stairs, and a water feature. (Scottsdale Historical Society.)

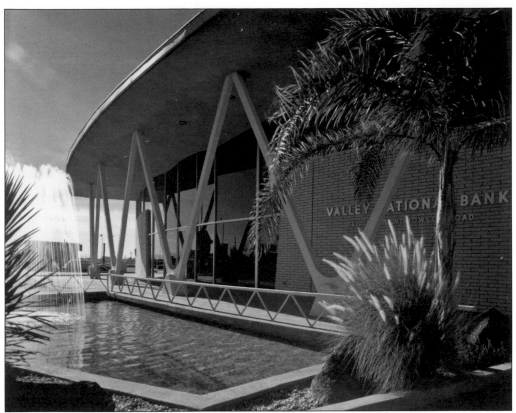

VALLEY NATIONAL BANK, 1962. The Valley National Bank designed by Cartmell and Rossman Architects at 7345 East McDowell Road provides a street identity with a transparent-glass front, a series of diagonal concrete struts supporting a thin roof lid, light-colored brick walls, and a reflecting pool. (SPS+ Architects.)

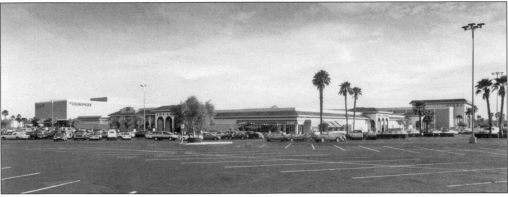

LOS ARCOS MALL, 1969. The Los Arcos Mall, a suburban air-conditioned mall, was located at the southeast corner of Scottsdale and McDowell Roads and was anchored by department stores. Smaller stores would also line the interior mall, a lower-level movie theater was provided, and ancillary structures were built closer to the streets. The character of the mall was a hybrid Spanish Colonial and Mediterranean Revival that struck a political balance between the Western revival and contemporary sensibilities of the time. It was constructed by Gilbert and Dolan Contractors. (Scottsdale Historical Society.)

SAVINGS AND LOAN. At 1920 North Scottsdale Road there is a 1960s small pavilion that has a symmetrical plan and is made of natural materials such as exposed concrete panels, glass at entries and corner windows, and capped with a thin floating cantilevered roof. The structure is on a raised concrete plinth and has cascading steps. The overall building proportions are very elegant and well scaled. (Author's collection.)

CAMELVIEW THEATER. At 7001 East Highland Avenue is a cluster of c. 1960s film theaters. A trio of custom fabricated and rusted-steel entry canopies of varying heights and diameters define the building. The main structure has battered walls composed of exposed marble chips. Details include expressive drainage scuppers with a vertical trough that led to a dish-like cistern. (Author's collection.)

ARIZONA BANK. This 1960s eleven-story Arizona Bank is located at 6900 East Camelback Road. It also housed retail and office space as well as a private penthouse. As one of three tall structures in downtown, it was used in a debate to cap structures at two stories and was successful for some time. The bank's character is a hybrid of vertical panels and angled horizontal glass bands, which when studied did respond to the sun's angles. (Author's collection.)

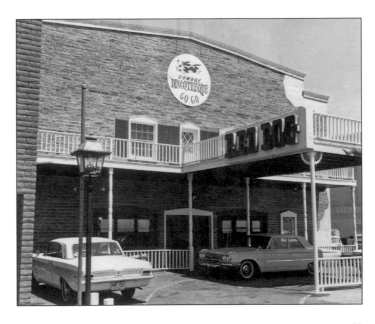

RED DOG SALOON, 1959. Bill Bird and Don Stewart opened the Red Dog Saloon and Restaurant at 4321 North Scottsdale Road. The restaurant respected the desired Western theme with exterior brick and plaster patch details. (Scottsdale Historical Society.)

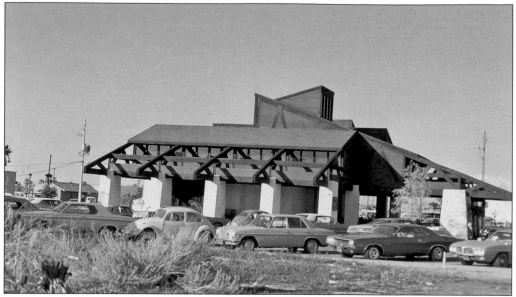

HATCHCOVER RESTAURANT, 1971. The Hatchcover Restaurant was located 4237 North Craftmans Court. The waiting area and kitchen were on the first level, and public dining with exterior terraces was on the second level. The design by architect Richard Caviness, Cooper Downs and Associates, was highly expressive with the triangulated heavy timber trusses resting on plaster piers. (Author's collection.)

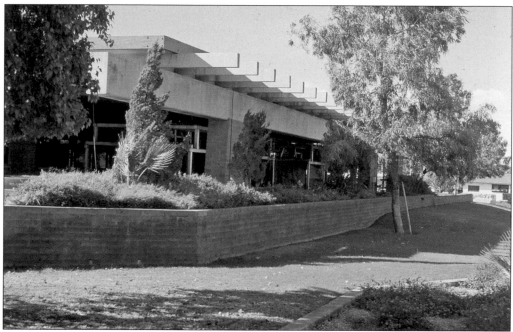

SCOTTSDALE CAR WASH, 1971. The Scottsdale Car Wash is located at 7501 East Indian School Road and is constructed of exposed concrete block, cantilevered concrete beams, and wood and glass infill. The architectural character for such a utilitarian function as a car wash was taken to a very expressive and sophisticated level by architect Richard Caviness, Cooper Downs and Associates. (Author's collection.)

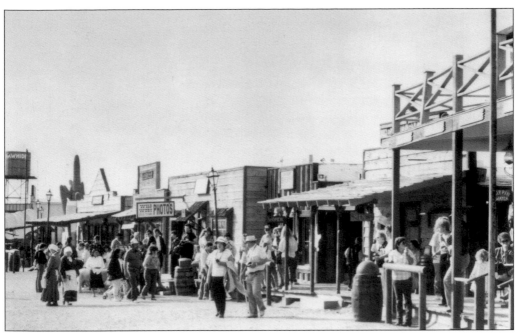

RAWHIDE, 1972. This recreated 1880s Western town was located at the southeast corner of Scottsdale and Pinnacle Peak Roads. To capture this tourist-oriented character, symmetrical facades, wood boardwalks, covered walkways, hitching posts, water towers, mine shafts, and barrel trash containers were provided. Jim Paul was the developer. (Scottsdale Historical Society.)

TAVAN ELEMENTARY SCHOOL, 1956. The K–8 Tavan Elementary School was located at 4610 East Osborn Road. During the late 1950s and early 1960s, over a dozen elementary schools were built in South Scottsdale to keep pace with the population influx. A prototypical design with a kit of building components was used, and each school was assembled slightly differently, adapted to each site and given a custom feature for an individual identity. Similar schools included Ingleside, Tonalea, Navajo, and Paiute, among others. (Scottsdale Historical Society.)

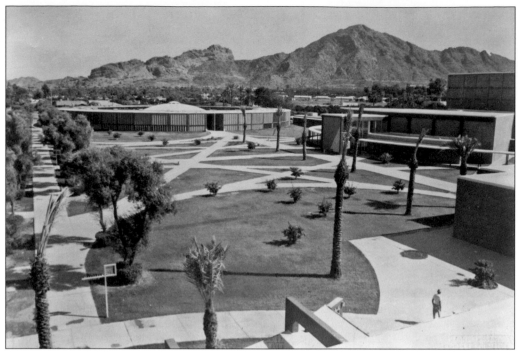

ARCADIA HIGH SCHOOL, 1959. The Arcadia High School campus was located at 4703 East Indian School Road and was comprised of one- and two-story buildings that used concrete structures with brick and glass infill panels. The donut-shaped classroom building with a round library centered in the plan was a creative building design by architect Mel Ensign. The exterior is clad in vertical metal-louver panels to control the direct solar angles from penetrating into the classrooms. (Scottsdale Historical Society.)

CORONADO HIGH SCHOOL, 1960. Coronado High School was located at 2501 North Seventy-Fourth Street and was constructed of structures using brick walls, concrete columns, waffle concrete roofs above the classrooms, and folded concrete plate roofs above the auditorium and gymnasium. The campus plan designed by architect Ralph Haver and Associates provided a main mall with classroom wings and larger structures running perpendicular to it. Its character was contemporary and crisp with the white structure expressed, capturing the optimism of that era. (Scottsdale Historical Society.)

SAGUARO HIGH SCHOOL, 1966. The Saguaro High School campus was located at 6250 North Eighty-Second Street. A large plaza and circulation connected the classrooms with gathering spaces such as the cafeteria, gymnasium, and auditorium. The structures were raised on platforms given the flood level, the walls were made of concrete panels, and the roof consisted of concrete tees with glass inserts. Natural concrete was complemented with colored accents. The architect was Pierson and Miller. (Scottsdale Historical Society.)

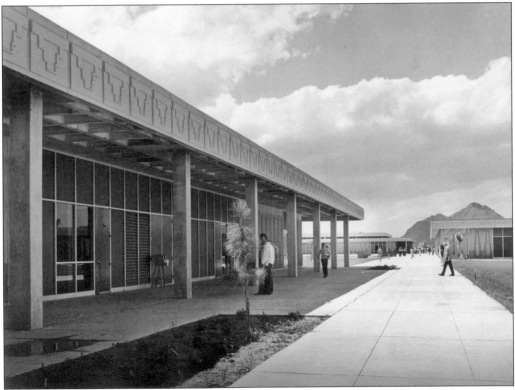

SCOTTSDALE COMMUNITY COLLEGE, 1970. The new 160-acre Scottsdale Community College campus is located at 9000 East Chaparral Road on Salt River Pima-Maricopa Indian Community land that was leased for 99 years. The entire campus plan by architect Weaver and Drover, with Richard Drover, Frank Henry, and Wallace E. Welch, was based on a 4-foot grid and a main mall with the first seven classrooms and student union building of 190,000 square feet. The theme was taken from Southwestern basket-ware patterns and is reflected in the concrete panels. (DWL Architects.)

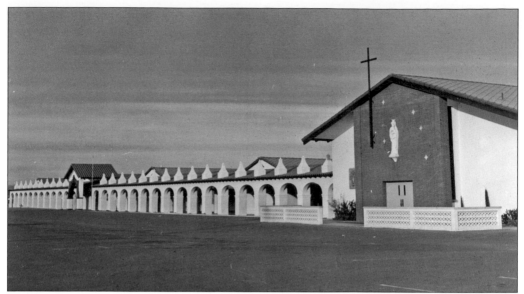

OUR LADY OF PERPETUAL HELP, 1956. Located at 7655 East Main Street, Our Lady of Perpetual Help began its first phase with a prototypical-designed chapel (right) with a school to follow. A larger church was required due to the parish's growth over the previous 20 years at the Brown Avenue Church. The character is Spanish Colonial Revival with off-white plastered walls, clay-tile roofs, and an arched arcade. (Scottsdale Historical Society.)

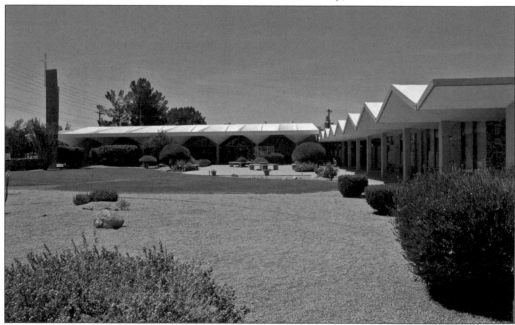

HOLY CROSS LUTHERAN CHURCH, 1961. Located at 3110 North Hayden Road, the sanctuary of the Holy Cross Lutheran Church addresses the street, and the school wings are set farther away. The structures are constructed of brick walls, glazing, and concrete columns. Roof structures are folded concrete plates at the school and a thin warped concrete shell at the sanctuary. The architect was William D. Knight Jr., who practiced locally from 1959 to 1963 and later served as the Navajo Nation architect. (Author's collection.)

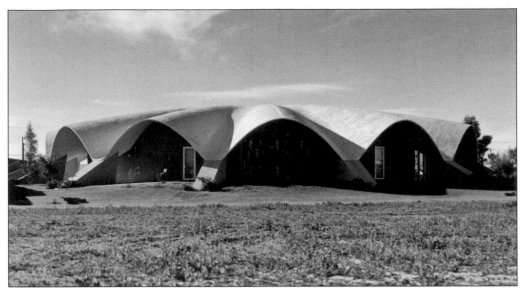

VALLEY PLAZA METHODIST CHURCH, 1966. The Valley Plaza Methodist Church was founded in 1963, and then the congregation constructed this church at 7425 East Culver Street. The church campus is composed of the sanctuary and classroom wings. The sanctuary, designed by Cartmell and Rossman Architects, was constructed of cast-in-place concrete buttresses supporting a radiating, compound-curved, and thin-shell concrete roof. The church is now the Los Arcos United Methodist Church. (SPS+ Architects.)

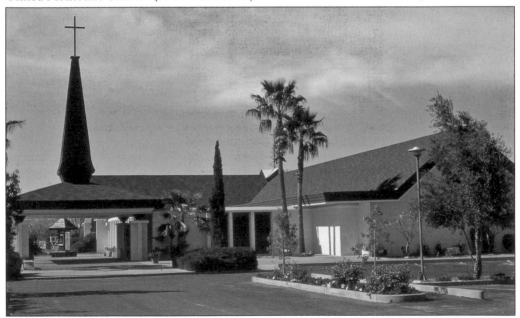

SCOTTSDALE UNITED METHODIST CHURCH. Founded in 1924, the Scottsdale United Methodist Church had earlier locations. Architect Fred M. Guirey designed the first phase of the 4140 North Miller Road location in 1956. In 1964, architect T. S. Montgomery designed this sanctuary through the inspiration of light and shadow: "I was driving in southern Arizona on a usual bright, sunny day when I crossed a bridge over a dry wash. I noticed the beautiful design of shadows in the sand made by the railings." (Author's collection.)

73

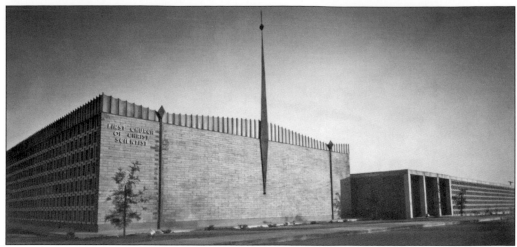

FIRST CHURCH OF CHRIST, SCIENTIST, 1962. Located at 6427 East Indian School Road, the 300-seat sanctuary and 34-classroom Sunday school of the First Church of Christ, Scientist, is composed of burnt-adobe walls, concrete units as grillage, a precast concrete roof structure, and copper fascia. The structure epitomizes an innate understanding of an appropriate scale, which is accomplished with natural materials and great skill. The church, designed by architect T. S. Montgomery, received the Valley Beautiful Citizens Committee Award in 1969. (First Church of Christ, Scientist.)

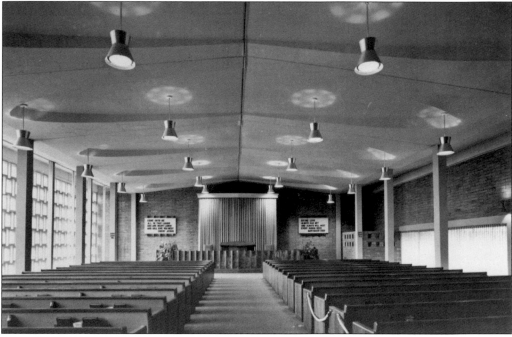

FIRST CHURCH OF CHRIST, SCIENTIST, SANCTUARY INTERIOR, 1962. Architect T. S. Montgomery designed the sanctuary interior of the First Church of Christ, Scientist, with full-height glass to the north and south and solid walls to the east and west to minimize heat gain during the summer months. Set outside the north wall are stacked precast concrete units forming a grill that prevents direct sunlight from penetrating the interior space while providing soft, diffused daylighting. (First Church of Christ, Scientist.)

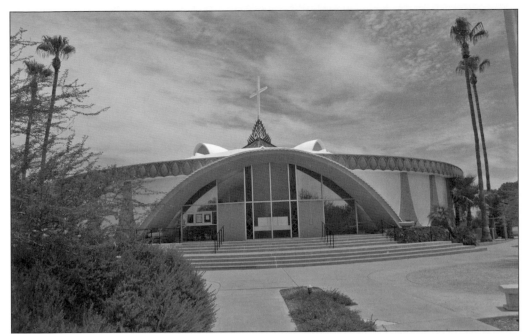

GLASS AND GARDEN COMMUNITY CHURCH. The 1966 Glass and Garden Community Church totaling 16,500 square feet is located at 8620 East McDonald Drive. The main sanctuary has a circular plan that was a "symbol of eternity for it has no beginning and no end." The church's dome is cast in 6-inch-thick concrete, which was completed in one day. It is a drive-in church where the choir and minister's voice can be heard by a special radio broadcast. The architect was E. Logan Campbell. (Author's collection.)

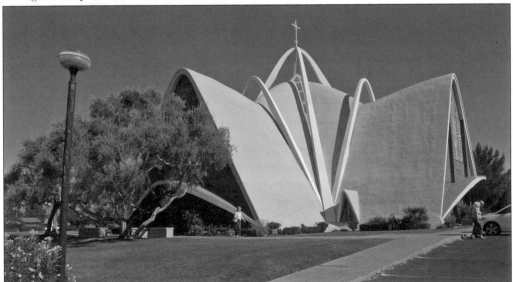

ST. MARIA GORETTI CATHOLIC CHURCH. The St. Maria Goretti Catholic Church was founded in 1967, and the church building designed by Wendell E. Rossman and Associates was constructed in 1972 at 6261 North Granite Reef Road. The cross-shaped plan has a 60-foot-high hyperbolic dome of thin concrete shells. The interior includes near-abstract mosaic Stations of the Cross, a balcony, an etched-glass image of the crucifixion suspended, and a pipe organ. (Author's collection.)

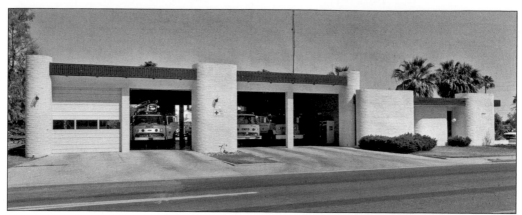

CITY FIRE STATION NO. 10. The City Fire Station No. 10 is located at the southeast corner of Miller and Thomas Roads. Construction includes four equipment bays, sleeping quarters, lockers, and offices. Materials include curved mortar-washed slump block walls that interrupt the roofline and a patterned fascia. (Scottsdale Historical Society.)

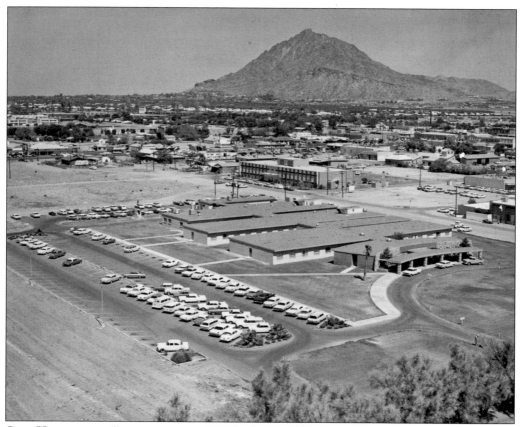

CITY HOSPITAL OF SCOTTSDALE, 1962. The hospital located at 7400 East Osborn Road was originally the City Hospital of Scottsdale in 1962, followed by Scottsdale Baptist in 1964, then Scottsdale Memorial, and eventually Scottsdale Healthcare Osborn. (Photos by Wes, Scottsdale Historical Society.)

McCormick Railroad Park.
In 1967, the Fowler McCormicks donated 100 acres of their ranch to the City of Scottsdale stipulating a park use. The McCormick Railroad Park was built at 7301 East Indian Bend Road; however, the size reduced to 30 acres when held within the city. Open in 1975, the oldest structure was salvaged from the 1920s Jolly Ranch and houses the model train collections. (Author's collection.)

Bennie Gonzales with Model.
The master model of the Scottsdale City Governmental Complex and architect Bennie Gonzales are pictured here in the mid-1960s. The model suggested how vast the architectural vision was for the campus over many downtown blocks. The character used angular elements for all site improvements and sculpted building forms. (Neil Koppes, Scottsdale Historical Society.)

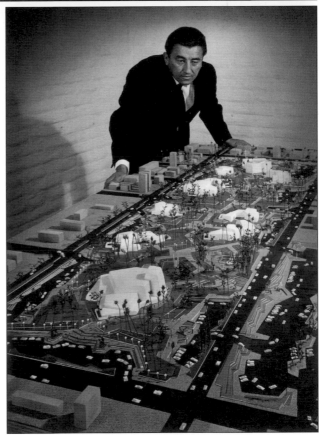

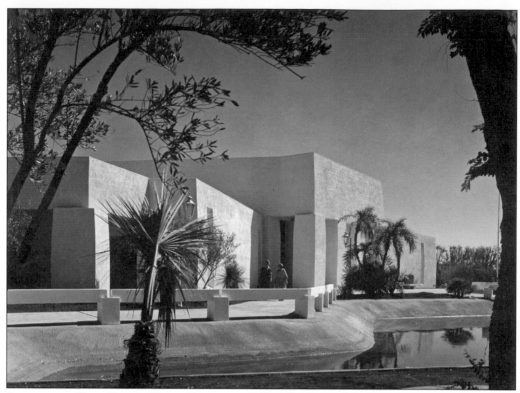

SCOTTSDALE CITY GOVERNMENT COMPLEX, 1968. The Scottsdale City Government Complex is located at 3739–3939 North Drinkwater Boulevard in downtown and includes a city hall and library. The award-winning campus designed by Bennie M. Gonzales Associates, Inc. consistently ranks high in all public polling as one of the most important architectural achievements. The contemporary interpretation of local forms and materials was a very fresh approach. Sculpted double thick walls, deeply recessed windows, and whiteness reflecting the summer heat is appropriate for the desert. (Barney Gonzales.)

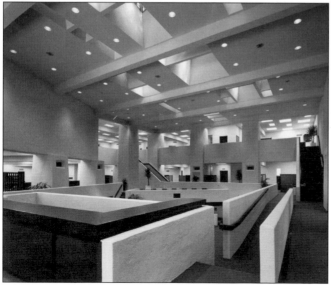

SCOTTSDALE CITY GOVERNMENT COMPLEX INTERIOR, 1968. The city hall interior was influenced by the Native American Kiva space that encouraged gatherings, which is achieved with an open plan, recessed floor, and top lighting with stained glass. The space captures the essence of a more demographic form of municipal government that encourages an open dialogue with its citizens. To many, this space designed by Bennie M. Gonzales Associates, Inc. is the most important community room in Scottsdale. (Scottsdale Historical Society.)

Four

ARCHITECTURE CHARACTER DEBATE AND INNOVATION 1973–1990

The early 1970s initiated a transition from more eclectic architectural styles to some acceptance of a modern sensibility as found in the Scottsdale Airpark. Revival styles continued in popularity, such as the Spanish Colonial and Mediterranean style at McCormick Ranch, and a Southwestern kitsch approach, such as Santa Fe Pueblo, appeared in numerous residential developments. In the late 1980s, the Estancia Development provided a Tuscan character, which proved to be very popular.

Preserving the McDowell Mountains became a growing concern with development moving north and potentially to hillside slopes. The 1977 Hillside Ordinance was adopted by city council to prevent construction above a certain slope, but it was challenged in court and did not hold up. In later years, an ordinance that offered incentives and traded higher residential units per acre at the lower slopes was enacted to avoid development at higher slopes. A 1981 Native Plant Ordinance was adopted where projects were required to document and salvage existing larger native trees and cacti.

Downtown revitalization within the governmental complex was a priority with the 1974 Civic Center Mall, the 1975 Scottsdale Center for the Arts, and the 1995 Civic Center Library expansion. They reinforced the functioning and symbolic heart of downtown Scottsdale while motivating other surrounding commercial development such as the 1975 Doubletree Inn resort.

In 1973, some new cultural institutions and activities were being born, including the Scottsdale Symphony and the Scottsdale Art Walk. Scottsdale Artists School was underway in 1983 and was effective with a nationwide reach in attracting students and teachers to Scottsdale. Another progressive program was the 1985 Per Cent for Arts Ordinance where on public facilities and larger private development they set aside 1 percent of the total construction budget for public art improvements. Numerous public art installations have occurred in the past 20 years for the betterment of the built environment.

The final land annexation of 36 square miles north of Scottsdale occurred in 1984 and brought the new total to 185. After the mid-1980s, a series of master-planning efforts occurred on larger parcels, and a couple of General Plan updates helped guide the character and uses of development.

HILLSIDE ORDINANCE, 1977. The City of Scottsdale adopted a hillside ordinance to protect the northern McDowell Mountains' hillsides from development. Unfortunately, a court case challenged the ordinance and it was invalidated, but future protections were put in place that proved effective. (Scottsdale Historical Society.)

PATRICK RESIDENCE, 1973. At 6628 East Exeter Boulevard, the street view of the Patrick residence exhibits a solid wall, but beyond this edifice is a courtyard that displayed the home's interior. The transparency of the U-shaped plan designed by architect Alfred Newman Beadle is spatially dynamic while being very simple—a balancing act that is extremely difficult. The steel structure is exposed throughout. (Arizona State University.)

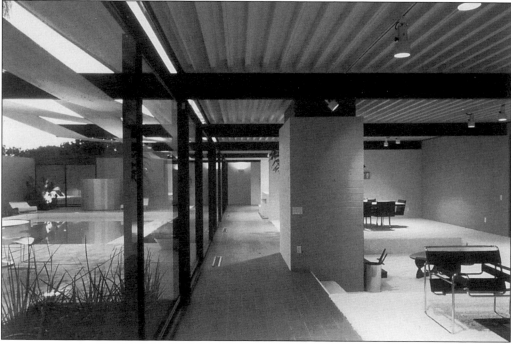

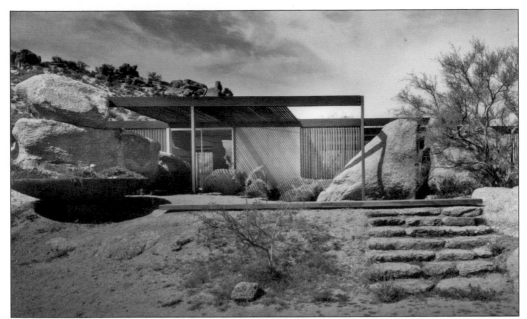

CORBUS RESIDENCE, 1978. The small Corbus residence is located on a 5-acre parcel at 11101 East Bajada Road. Architect Edward B. Sawyer Jr. explains that the "owners desired a small home that could be phased to grow with their family. In love with the desert and its subtle seasonal changes, they felt compelled to be as 'available' to the environment as possible. The home was designed to float above a desert ravine creating a matrix that uses the natural boulders to form and define various living experiences." (Robert C. Cleveland, Edward B. Sawyer Jr.)

FOCUS HOUSE, 1986. This 4,300-square-foot residence designed by Taliesin Architects is located on 1.51 acres within the Taliesin Gates luxury residential community at 108th Street and Cactus Road. All walls have a fluted texture that self-shades and is similar to Saguaro cactus ribs. The roof is low-pitched copper with a thin profile that overhangs. Glass is deeply recessed and protected from the harsh sun. (Scottsdale Historical Society.)

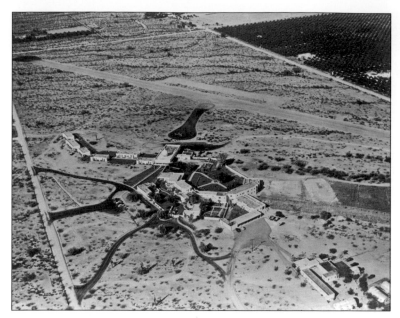

KELLOGG RESIDENCE, 1932. Located at 5101 North Sixty-Sixth Street, the original Donald Kellogg residence by architect Robert Evans on 20 acres was purchased by George W. Borg of Borg-Warner, who added a private airstrip. In 1946, it underwent an addition to become a 30-room inn named Casa Blanca, famous for its Moroccan domes. (Scottsdale Historical Society.)

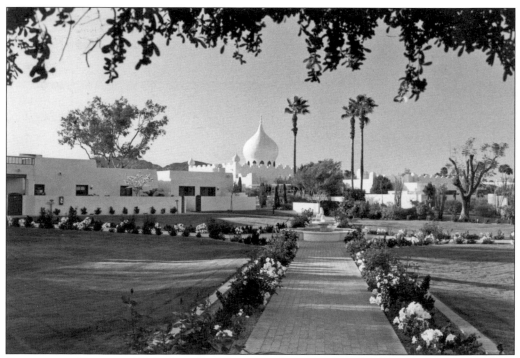

CASABLANCA ESTATES, 1982. An award-winning adaptive reuse of the original Donald Kellogg residence by architect Christensen, Roberts, and Jones was completed and includes 72 casitas with an added 57 luxury condominiums. Much of the original features such as the wood beams, adobe walls, and swimming pool were preserved. (Scottsdale Historical Society.)

THE HERITAGE, 1986. At 4200 North Miller Road, the Heritage, a five-level structure with 219 residential units, is one of the first downtown developments to test a greater building height. Produced by Reyerson Development, the Spanish Colonial Revival style is reflected in the plastered walls, tile roofs, and clay grilles. Volume is mitigated with varied elevations, balcony railings, recessed glazing, smaller windows, and a broken roofline. (Scottsdale Historical Society.)

SUNSCAPE APARTMENTS, 1982. The Sunscape Apartments, a multifamily development with over 500 units in two- and three-story components, is located at 3500 North Hayden Road. The site plan was well conceived by architect Fisher Friedman Associates of San Francisco, California, providing a landscaped berm to screen the parking, smaller parking lots, building clusters, and units that expressed individuality. The development was constructed of wood framing, plaster walls, wood lattice, and blue awnings. (Author's collection.)

INDIAN BEND GREENBELT, 1973. This photograph looks north of Chaparral Road with Hayden Road to the left. Citizens and the city took the initiative to not accept a proposed concrete-lined channel for flood control. The sensitively planned Indian Bend Greenbelt with landscaped open spaces, golf courses, recreational facilities, and walkways transformed 7 miles of Scottsdale. Private property rights were protected by exchanging higher densities at the greenbelt edges for allowing city development rights within the wash. (Scottsdale Historical Society.)

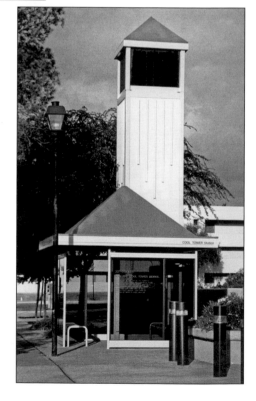

COOLING TOWER. At 7447 East Indian School Road, the city had this experimental bus stop and cooling tower temporarily built to demonstrate the technological possibilities at cooling the air. Produced by Tucson-based Cool Tower Systems, air is drawn down into the top, picks up moisture, and then drops for those waiting. (Scottsdale Historical Society.)

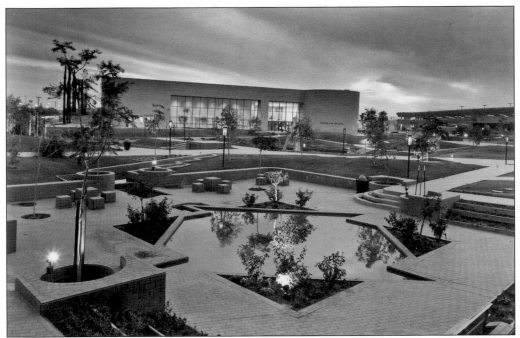

CIVIC CENTER MALL, 1974. The downtown redevelopment area was transformed with grassed berms, paved walkways, water features, shade trees, performance spaces, and public art. In the foreground is the rose garden with the Scottsdale Center for the Arts beyond. Improvements provided a landscaped setting and pedestrian experience. An original Mexican barrio was removed to construct such improvements. The architect for this project was Richard Caviness, Cooper Downs and Associates. (Scottsdale Historical Society.)

SCOTTSDALE CENTER FOR THE ARTS, 1975. Located at 7380 East Second Street, the Scottsdale Center for the Arts 90,000-square-foot facility accommodates galleries, a 200-seat cinema, and an 850-seat performing arts theater. A lobby atrium hosted innumerable events, thereby becoming one of the most important public rooms in the city. Curving walls, public entries, and clerestories above define the atrium designed by architect Bennie M. Gonzales Associates, Inc. with Ralph Harris. (Scottsdale Historical Society.)

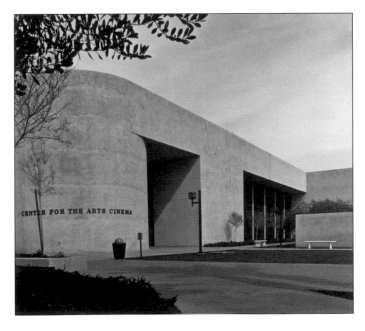

Tournament Players Club of Scottsdale, 1986. The Tournament Players Club (TPC) of Scottsdale's golf clubhouse provides a restaurant, locker room, and pro shop. It is the focal element for two TPC golf courses designed by Tom Weiskopf and Jay Moorish. The club, designed by Allen and Philp Architects, was constructed of plastered walls with warm colors, medium-pitched roofs, glazed gables, and shade trellises at exterior terraces. (Allen and Philp Architects.)

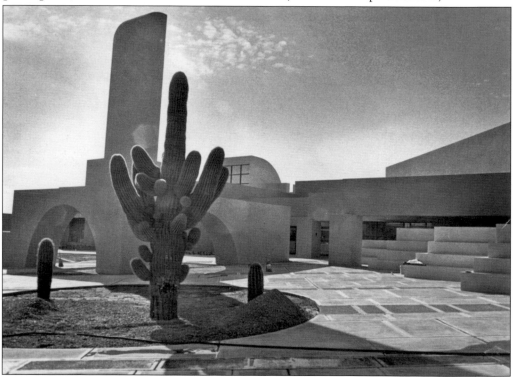

Mustang Branch Library, 1987. Located at 10101 North Ninetieth Street, the 31,850-square-foot Mustang Branch Library provided collections, a children's area, an auditorium, a story room, periodicals, reference material, reading, and patios. The exterior has plastered walls, recessed glazing, clerestory monitors, and desert landscaping. The first public art project was the 1989 *Mustang Wall* by Ken Williams, a bas-relief sculpture in clay brick of galloping ponies. The library's architect was Dean, Hunt, Krueger, and Associates, Inc. (Scottsdale Historical Society.)

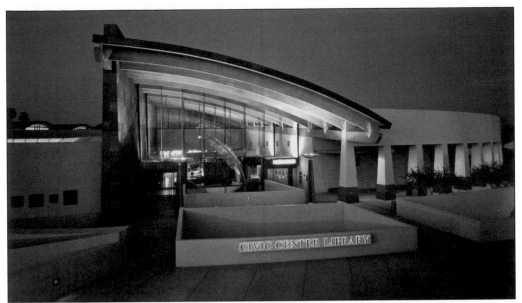

CIVIC CENTER LIBRARY ADDITION, 1995. The 59,000-square-foot Civic Center Library expansion is located at 3939 North Drinkwater Boulevard and provides a reading room, 280-seat auditorium, youth services and story time areas, and a Southwest room. It was constructed of plastered masonry, glu-lam beams, tall glazing, and clerestories. Public art includes the interior *Pillars of Thought* by Mags Harries and Lajos Heder and the exterior *Imagination Gives Us Wings* by Larry Kirkland. The design challenge was to have it be sympathetic to the original Bennie Gonzales–designed library. The firm that designed the expansion was Anderson, DeBartolo, and Pan, Inc. Architects. (Jim Christy Studio, Scottsdale Public Library.)

DOUBLETREE INN. The 1975 Doubletree Inn is constructed at 7353 East Indian School Road facing the Civic Center Mall. The three-level complex designed by architect Peter A. Lendrum and Associates includes guest rooms, meeting facilities, a lobby, and exterior courtyards. Rooms are accessed by outdoor breezeways, and parking areas are screened from the street. The structures are constructed of plastered walls and deeply recessed windows that respect the sun's angles. (Author's collection.)

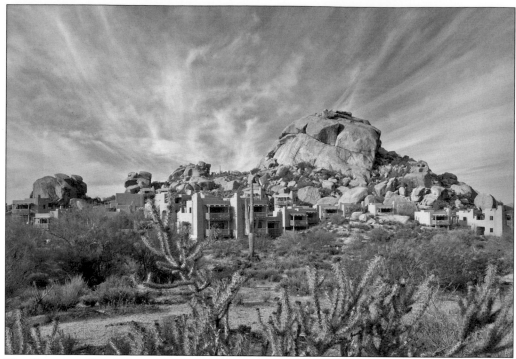

THE BOULDERS RESORT, 1985. The Boulders Resort is located at 34631 North Tom Darlington Drive on a spectacular granite boulder-strewn site. The architectural character visually blends with the natural setting and has strong shadows, and desert landscaping. Its uses include restaurants, a golf clubhouse, rental units, and a golf course. Architect Bennie Gonzales Associates, Inc. composed the master plan for the resort, and Allen and Philp Architects designed the structures. (Allen and Philp Architects.)

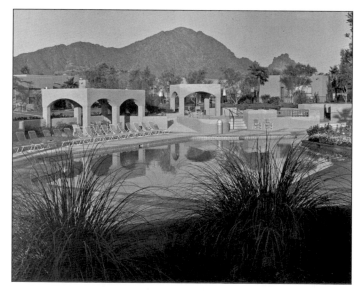

RENAISSANCE COTTONWOODS RESORT, 1980. The two-story Renaissance Cottonwoods Resort is built at 6150 North Scottsdale Road. The character is southwestern with painted-plaster forms, flattened-arch openings, deeply recessed windows, and oasis-like courtyards. Architect Bennie M. Gonzales Associates, Inc. designed the resort and was also responsible for the 1976 Scottsdale Conference Resort on McCormick Parkway. (Hal Martin Fogel, Scottsdale Historical Society.)

LOEW'S PARADISE VALLEY RESORT, 1984. Loew's Paradise Valley Resort and meeting facility is located at 5401 North Scottsdale Road. The two-story complex consists of a series of smaller buildings arranged around courtyards, patios, and linear passageways. The exterior wall material is an exposed, colored, and custom-formed masonry unit that provides a very textured wall and cools it down during the summer. (Author's collection.)

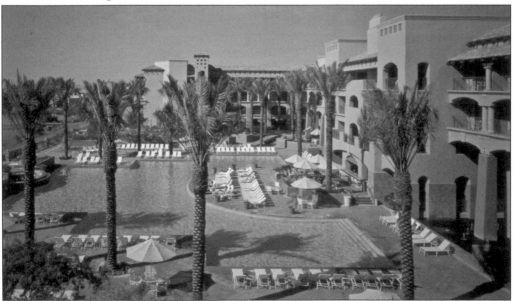

PRINCESS RESORT, 1987. At 7575 East Princess Drive, the sprawling Princess Resort and meeting facility was designed by Allen and Philp Architects with a series of wings interlocking with exterior courtyards of varying characters. Its scale is broken down with towers; stratified elevations; and a variety of balcony, window, and wall openings. An eclectic style made references to Spanish, Colonial, and Mexican haciendas. Materials are colored plaster walls with a stone base, clay roof tiles, concrete columns, and custom metal railings. (Allen and Philp Architects.)

MARRIOTT SUITES SCOTTSDALE, 1988. Located at 7325 East Third Avenue in downtown, the Marriot Suites Scottsdale provides 251 residentially designed suites. At eight stories, the height is mitigated by creating a roof profile that stepped down toward the streets, integrated differing masonry wall colors, and provides a shaded arcade. (Scottsdale Historical Society.)

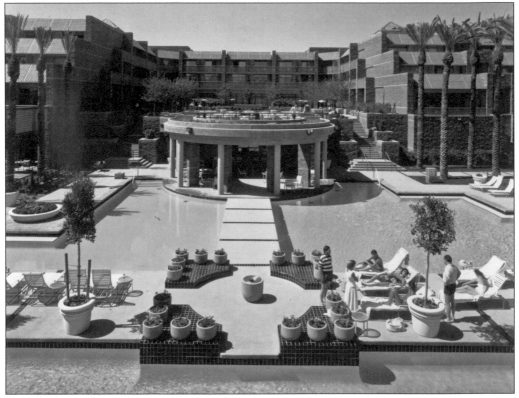

GAINEY RANCH HYATT REGENCY, 1987. The Gainey Ranch Hyatt Regency resort is located at 7500 East Doubletree Ranch Road and is a major shift away from the 1970s Spanish Colonial Revival style. The entry sequence was choreographed from the street to the lobby, landscaped terraces, expansive pools, golf course beyond, and ultimately the McDowell Mountains view. Guest wings wrap around various landscaped courtyards. Architect Hornberger + Worstell of San Francisco, California, portrayed a contemporary character with masonry walls and wood shading grills. (Scottsdale Historical Society.)

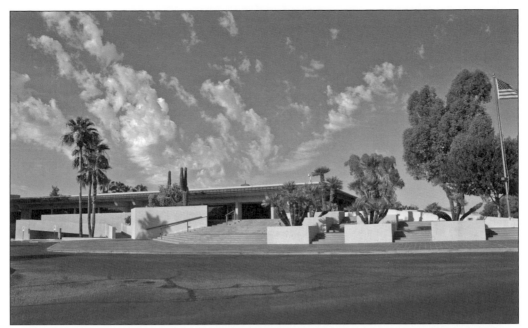

SENTRY INSURANCE. At 9501 East Shea Boulevard, the Sentry Insurance structure was built in 1973 with plastered walls, low-pitched metal roofing, terraces, landscaping, and shaded parking. A fitness center for employees' use was provided—a new precedent at the time. The architect was Haver, Nunn, and Nelson. (Author's collection.)

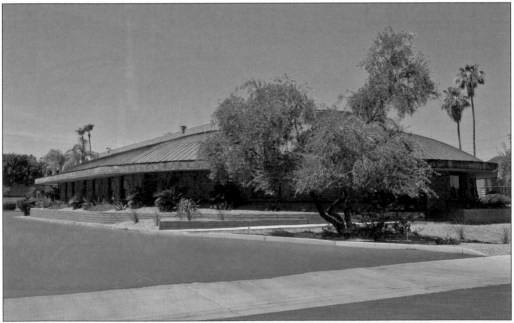

SCOTTSDALE CARDIOVASCULAR CENTER. The 1983 Scottsdale Cardiovascular Center is constructed at 3099 Civic Center Plaza and was a low-profile structure. The client required that the building be unique in its appearance so that it could be easily described and recognized by patients seeking the center's services. Materials are slump block and precast concrete walls and a copper roof. The architect was Kamal Amin Associates. (Author's collection.)

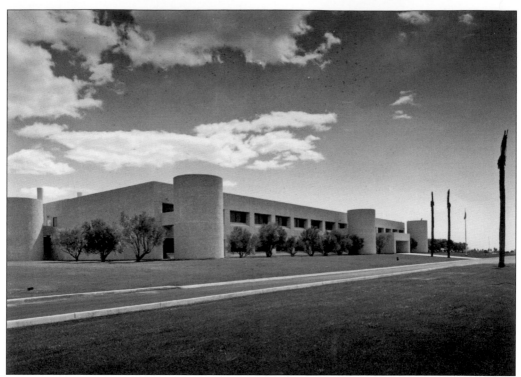

ARMOUR DIAL RESEARCH CENTER, 1976. At 15101 North Scottsdale Road, the Armour Dial Research Center and corporate administrative structure had a front elevation designed by Bennie M. Gonzales Associates that was animated with shafts for exit stairs. The main building had plastered walls and deeply recessed horizontal windows that introduced natural lighting. (Scottsdale Historical Society.)

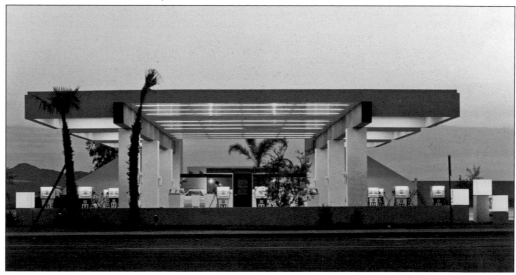

SELF-SERVE GAS STATION, 1973. This gas station and convenience store is located at 10200 North Scottsdale Road. The station is composed of a bold floating-roof structure and a store with a pitched-roof form that rose to the canopy and transformed the typical gas station of its time. It was designed by architect Wilson Jones and Associates. (James Cowlin, Jones and Mah Architects, Inc.)

ELAINE HORWITCH GALLERIES, 1978. The Elaine Horwitch contemporary gallery was located at 4211 North Marshall Way in downtown and became an award-winning 3,500- square-foot structure with public exhibition space. The design by architect James A. Roberts, AIA, with George M. Christensen and Associates exploited the use of daylighting and included finishes such as exposed concrete floors, wood structure, and display lighting. (Author's collection.)

SUPERPUMPER GAS STATION, 1982. This first 1,580-square-foot station is located at Fiftieth Street and Shea Boulevard. The American Institute of Architects Awards's jury stated, "A mundane ubiquitous act, buying gas, is transformed into high theater. Advertising and function are well blended in a high-speed milestone . . . A gas station that not only makes a positive contribution to the quality of its surroundings, but also gives its customers the sense that they and not their automobiles are what is important in this commercial environment." The architect was Jones and Mah Architects, Inc. (Michael Reese Much, Jones and Mah Architects, Inc.)

AZ 88. The AZ 88 restaurant and bar was built in 1988 at 7353 Scottsdale Mall. These renovations set a new, fresh standard with a crisp white interior, tall mirrored wall, ghosted columns of rusted steel, large picture windows to view the Civic Center Mall, and temporary art installations by Janis Leonard. The original project was by designer Michael Johnson, and the exterior patio was by architect John Chonka. (Author's collection.)

EL PEDREGAL, 1989. Located at the southeast corner of Scottsdale Road and Carefree Highway, El Pedregal—a specialty retail center designed by Architectonics and developed by Westcor—has art galleries, restaurants, retail, and later a Heard Museum. The plan focuses on a terraced courtyard with a fabric structure above. The character is an interpretation of African villages with thick walls, towers, soft forms, warm colors, railing openings, and bold accents. (Author's collection.)

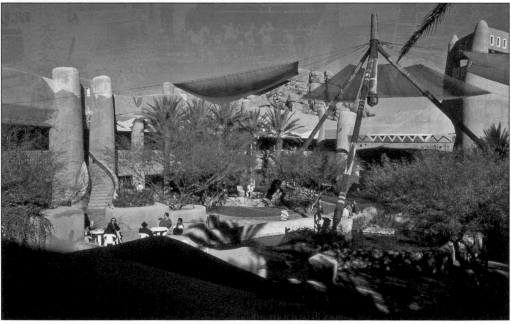

SCOTTSDALE GALLERIA, 1989. The four-level Scottsdale Galleria retail complex is located at 4343 North Scottsdale Road and is composed of upscale boutiques and restaurants that are bisected by a street. The exterior includes shaded arcades and stepped back sections with balconies. The interior provides a large atrium with public art water as its focus and skylights. The design architect was Design International of Indianapolis, and the local architect was Architecture One. (Author's collection.)

GAINEY FINANCIAL CENTER, 1986. Development of the Gainey Financial Center was placed over a parking structure and set a new standard for speculative office projects. A series of plastered-fin walls, recessed glazing, natural stone base, shadows, patterned walks, and palm trees delivered an appropriate structure. The architect was Cornoyer-Hedrick, Inc. (Author's collection.)

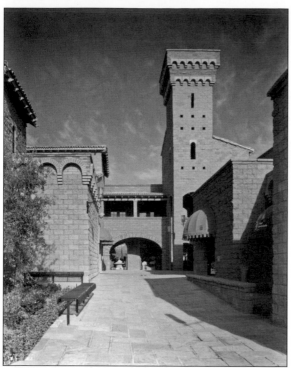

THE BORGATA, 1981. This 7.5-acre site at 6166 North Scottsdale Road is home to The Borgata, an 89,800-square-foot retail center that was influenced by the Italian hill town of San Gimignano. Seven towers mark the entrances, and patrons pass through a "wall." Upon entering, the narrow well-scaled pedestrian streets and courtyards provide orientation for shop fronts and encourage "cross-shopping." Arched wall openings, rustic masonry, and clay-tile roofs capture the desired character. Jones and Mah Architects, Inc. designed this unique retail center. (Wayne Thom Associates; Jones and Mah Architects, Inc.)

PABELLON OFFICE, 1986. The Pabellon Office is located at 8700 East Via De Ventura. A stepped form with outdoor terraces faced the street intersection and provides a transition to the higher forms. The office was designed by Holabird and Root of Chicago, Illinois, a very prominent firm founded in 1880 that received the 1983 American Institute of Architects Architectural Firm of the Year Award. (Author's collection.)

UNITED BANK BUILDING, 1989. Located at 7150 East Camelback Road, the United Bank building anchors a retail development at a Scottsdale Road intersection and includes banking services and offices. The location of this mid-rise structure and its height initiated a debate about downtown building heights. The architect was Architectonics. (Author's collection.)

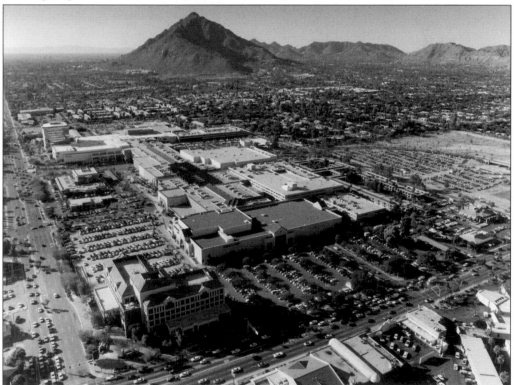

SCOTTSDALE FASHION SQUARE EXPANSION, 1998. This regional downtown, air-conditioned mall has grown to over 225 stores, with a retail floor area of 2,050,600 square feet, and has one of the highest retail sales per square foot in the United States, which has greatly benefited downtown Scottsdale. The interior had three levels topped with extensive skylights, which made for a dynamic ambiance and captured the movement of people. (Gray Photographic, Inc.; Scottsdale Historical Society.)

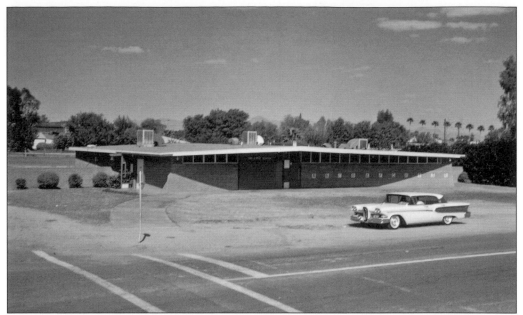

LOLOMA SKILLS CENTER, C. 1960S. The Loloma Skills Center was for grades nine through twelve. The building had a contemporary character, was constructed of exposed masonry walls, horizontal glass, and a low-pitched roof with broad overhangs and was conditioned with evaporative coolers. (Scottsdale Historical Society.)

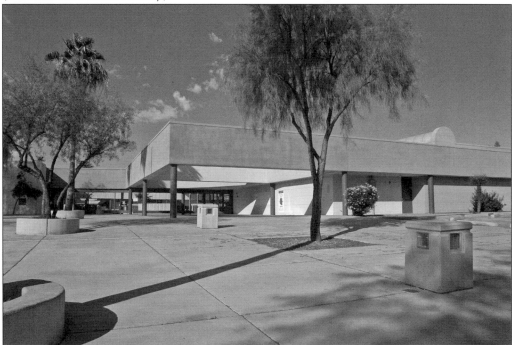

LAGUNA ELEMENTARY SCHOOL, 1986. The Laguna Elementary School was designed for kindergarten through sixth grade and is composed of classroom wings and offices accessed by outdoor circulation spaces. The exterior has painted-plaster walls, steel columns, vaulted skylights, and railings. The Lescher and Mahoney/DLR Group designed the school. (Author's collection.)

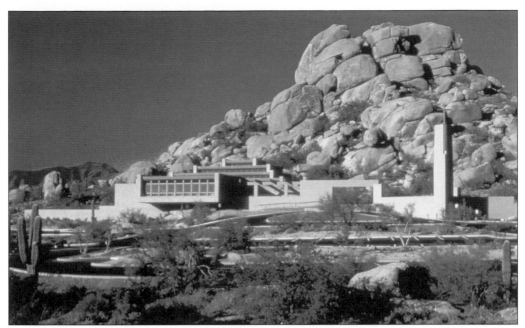

DESERT HILLS PRESBYTERIAN CHURCH, 1988. The Desert Hills Presbyterian Church located at 34605 North Scottsdale Road is a horizontally composed structure designed by Roberts/Jones Associates, Inc. with an enclosed sanctuary to the west end, a defined entry plaza, and visually screened parking. Plastered walls, recessed glazing, and wood beams are fitting for the dramatic granite boulders. (Roberts/Jones Associates, Inc.)

WINDOWS TO THE WEST, 1973. The *Windows to the West* public art piece by Louise Nevelson is located on the Civic Center Mall in a water feature, surrounded by an amphitheater. The character is architectonic by being very orderly and geometric but offered variety. Rusted steel was used as a visual reference to early Scottsdale structures. It is among other art pieces that have contributed positively to the built environment. (Scottsdale Public Library.)

YARES GALLERY, 1988. The Yares Gallery and residence is located at 3625 North Bishop Lane. Its expansion included an adobe structure that was the original gallery founded in 1964. The nature of the mixed-use gallery designed by Jones and Mah Architects, Inc. was highly unusual at the time. The form consisted of cubic volumes, a vaulted entry, and roofs with pyramidal gallery skylights. (Douglas Kahn; Jones and Mah Architects, Inc.)

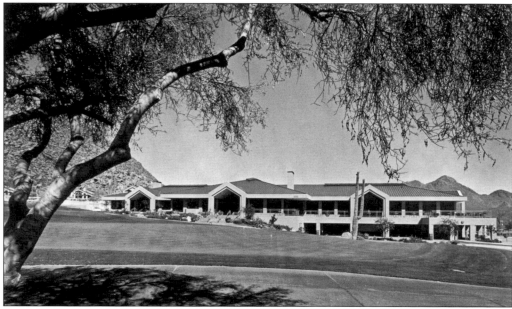

TROON GOLF AND COUNTRY CLUB, 1986. Located in the Pinnacle Peak area, the Troon Golf and Country Club facility supported the adjacent golf course. Its uses include a lobby, pro shop, dining facility, locker rooms, and exterior terraces. The character is post-modern with pediment-framed elements, plaster walls, medium-pitched roofs, and custom railings. The architect was Cornoyer-Hedrick, Inc. (Scottsdale Historical Society.)

DESERT MOUNTAIN GATEHOUSE, LATE 1980s. The Desert Mountain development is located in northern Scottsdale in an area annexed in the 1980s. The gatehouse set the tone for this master-planned community. The materials are natural with stone walls, wood beams, and outreaching plastered walls, and the forms suggest they were influenced by southwestern ruins. (Author's collection.)

SCOTTSDALE MEDICAL AND PROFESSIONAL CENTER, 1960s. Located at 7350 East Stetson Drive, the Scottsdale Medical and Professional Center has wings that intersect at an outdoor breezeway. The exterior atrium is defined by walls, an elevator shaft, an open stairway, and a roof lid in a pleasant choreographed manner. A cooler microclimate was achieved with the shading and breezes that move through the space. The materials are slump-block walls, aluminum windows, horizontal louvers, and a patterned concrete fascia. (Scottsdale Public Library.)

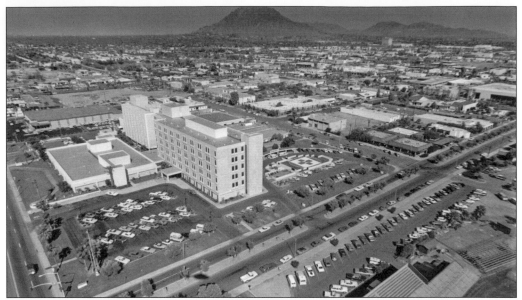

SCOTTSDALE MEMORIAL HOSPITAL, 1970s. At 3501 North Scottsdale Road, the 1962 Scottsdale Memorial Hospital grew to a 120-bed hospital for a 1970 population of 67,800. A series of expansions included a multilevel nursing unit tower, medical offices, parking structures, surgery centers, and corporate offices. A new Primary Level I Trauma Center for the east valley with a helipad, the 2003 freestanding surgery center, and the 2005 Primary Stroke Center have been completed. The architect for the vertical expansion was Guirey Srnka Arnold and Sprinkle Architects. (Scottsdale Public Library.)

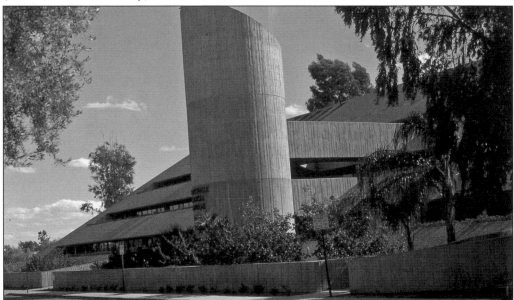

SCOTTSDALE MEDICAL PAVILION, 1977. The Scottsdale Medical Pavilion is located at 7331 East Osborn Road and is a four-level medical office building. The medical suites are within a wedge-shaped concrete structure, which offered varying tenant suite depths. The wedge is visually complemented by a truncated cylindrical shaft that houses the elevator. The architect was Michael and Kemper Goodwin, Ltd. with Jeremy Jones, AIA. (Jeremy Jones, AIA.)

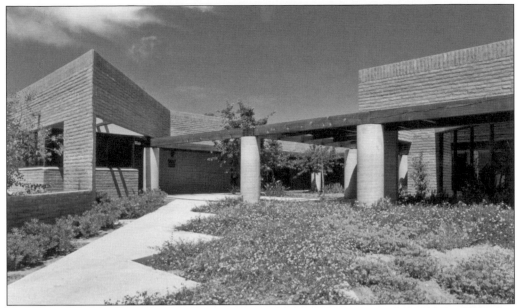

PLAZA DE LOS MEDICOS, 1980. The Plaza de los Medicos complex is located at 7514 East Monterey Way and was designed by architect George W. Christensen and Associates. The plan includes 10,000 square feet that focuses on a southwestern courtyard with shade trees. Traditional materials used in a contemporary manner are slump block, concrete columns, and a wood-shade canopy. (A. F. Payne Photographic, CCBG.)

MEDICAL ARTS BUILDING, 1987. The Medical Arts Building is a partially submerged structure located at 7500 East Angus Drive. The exterior has landscaped earth berms to the street, and the interior is partially improved with a dental suite. The materials are sandblasted masonry, exposed steel, recessed horizontal windows, and a pitched metal roof. Trees were planted on the east and west exposures and at entrances for sun control. The architect was Michael Shelor. (Michael Reese Much.)

SCOTTSDALE MEMORIAL HOSPITAL, 1984. Known as Healthcare North, this large Phase I medical campus is located at 9003 East Shea Boulevard. A linear floor plan, designed by architect NBBJ, with rotated nursing units reduced the massing of this multilevel hospital and defined triangular-shaped patios. The exterior materials are tan-colored plaster walls, recessed window frames, and custom steel at stairs and railings. A plan was staged for future expansions, which have occurred. (Scottsdale Historical Society.)

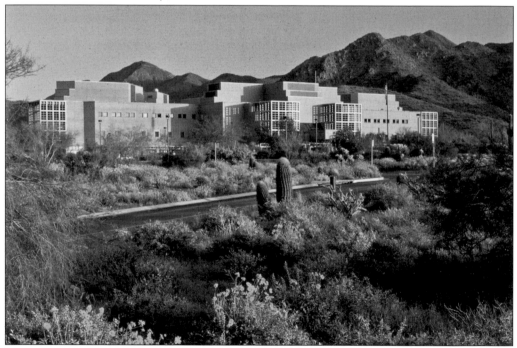

MAYO CLINIC SCOTTSDALE, 1987. The Mayo Clinic is located on East Shea Boulevard in the upper Sonoran Desert. As a multidisciplinary, multigroup practice, the clinic houses 30 physicians including 120 examining rooms, a pharmacy, cafeteria, and auditorium. In addition, a telecommunications system and video-conferencing center was provided. A stepped-roof profile and horizontal massing of plastered walls, stone accents, and steel shade grilles designed by architect Ellerbe Beckett of Rochester, Minnesota, help mitigate the volume. (Scottsdale Historical Society.)

Five

TRANSITION INTO THE 21ST CENTURY
1990–2008

By 1990, the Scottsdale population had grown to about 130,000 and by 2008 to about 240,000. During this time, some regional transportation connections were made such as the 1995 Pima Freeway/Loop 101 opening north to Thomas Road. Before this time, Scottsdale was somewhat isolated and finding access to surrounding communities was more difficult with only surface streets being available.

Citizens were concerned about the built and natural environments, and it triggered a number of city initiatives. During the next decade, the Save McDowell Mountains campaign was underway, and in 1991, the Environmental Sensitive Lands Ordinance (ESLO) was put into effect to set aside natural desert areas within new developments. In 1995, there was a momentous, unprecedented event when the city would set aside one-third of its total land area for a natural desert preserve in such a short span of time. This was achieved by the Scottsdale citizens voting for a two-tenths of one percent sales tax increase to fund land purchases for the McDowell Mountain Preserve. The first land purchase occurred in 1996.

Built environments sought certain protections including the 1999 adoption of the Historic Preservation Ordinance. That same year, the city adopted the Archaeological Resources Ordinance, which was the first municipality in Arizona to do so. In 1995, the CityShape 2000 General Plan Review process was accomplished and helped guide the city's future. Movement toward being more sustainable as a community was starting to take hold, and the City of Scottsdale adopted the City Green Building Standards for residential projects in 1998 and for commercial buildings in 2001. The City of Scottsdale also wanted to lead by example, so it was the very first city in the United States to require all future municipal facilities to meet Leadership In Energy and Environmental Design (LEED) Gold Level certification in 2005. This certification level is very aggressive at being more energy efficient and environmentally sensitive. Architecture during this transitional phase from the end of the 20th century and into the 21st century became more innovative and experimental.

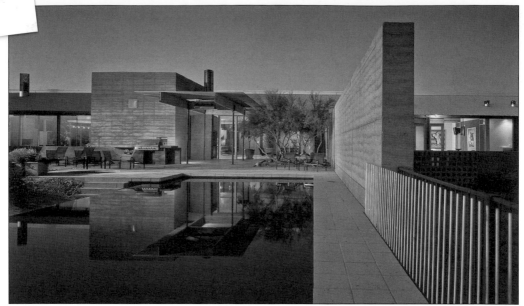

LOW COMPOUND, 1997. A large winter residence is situated on 10 acres where the functions among several buildings is to preserve the existing Palo Verde trees, Saguaro cactus, and natural drainage patterns and to capture spectacular views. The use of unique materials included rammed-earth walls, rusted siding, metal roofing, and glass, thereby "creating a structure that is at once earth bound and airy," as stated by architect Eddie Jones, AIA, of Jones Studio, Inc. Eddie Jones also designed the Scorpion, Walner-Reimers, and Logan residences. (Jones Studio, Inc.)

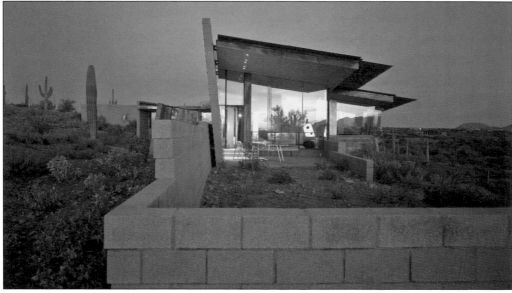

BYRNE RESIDENCE, 1998. The Byrne desert house was sensitively sited by architect Will Bruder to provide good sun orientation, retain the natural surroundings, and maximize views. It was constructed of exposed and battered masonry walls, low-pitched metal roofs with cantilevered edges, full-height glazing, and outreaching site walls. Crafted details are found throughout including the shifted block, skylight slot where the roof meets the primary wall and dramatic lighting. (Bill Timmerman, Will Bruder Architect.)

106

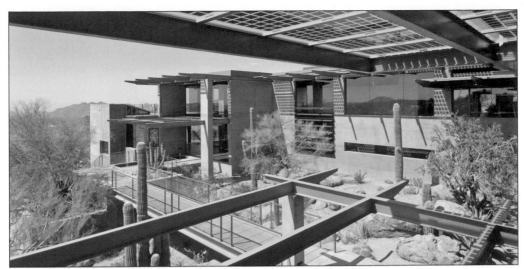

STERLING RIDGE RESIDENCE, 2004. The 12,607-square-foot Sterling Ridge residence was composed of concrete walls, sheltered glazing, exposed steel beams, and cantilevered canopies. Crafted detailing included a steel bridge and solar photovoltaic cells above to filter the sun. The character was contemporary with a palette of natural and durable materials. Architect David C. Hovey, FAIA, who worked on this project, also designed the Shadow Caster and Cloud Chaser residences. (Bill Timmerman, Optima, Inc.)

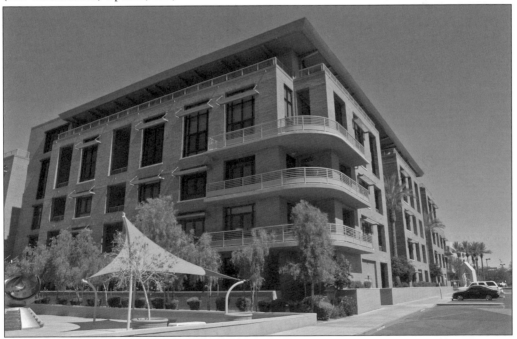

THIRD AVENUE LOFTS, 2002. The Third Avenue Lofts are located at 7301 North Third Avenue and have a courtyard floor plan. The courtyard is ringed by 88 units that rise five levels above grade with parking below. The project, designed by Woosley Studio, Inc. is one of the first downtown contemporary loft-living developments with flexible, open, and high-ceilinged units. The exterior is a contextual brick, and the floors are concrete expressed at the edges and balconies. (Author's collection.)

LOLOMA 5, 2004. Loloma 5 is a multifamily residential development located at 3707 North Marshall Way. Five 3-level condominium buildings designed by William P. Bruder + Partners, Ltd. are oriented to Camelback Mountain views with a carport below and living space above. A palette of exposed masonry, natural metal siding, perforated panels, tall glazing, and accent colors was used. The site used granite drives, desert landscaping, and Ocotillo fencing to screen the neighboring building. (Bill Timmerman; William P. Bruder + Partners Ltd.)

THE DUKE, 2006. The Duke, a 13,632-square-foot multifamily residential development, is located at 7047 East Earl Drive in a transitional neighborhood. Eight 3-level work/live townhomes were assembled within a compact, box-like volume. Units are spatially efficient and articulated with crisp details. Circle West Architects, P.C. addressed sustainable design by participating in Scottsdale's Residential Green Building Program. (Jesse Rieser, Rieser Photography; Circle West Architects, P.C.)

SAFARI DRIVE. Safari Drive, a 4.86-acre mixed-use neighborhood, is located at 4747 North Scottsdale Road. The 2009 plan includes eight structures with live/work lofts, flats, and townhomes ranging from 800 to 2,400 square feet with retail space. Residents can access a business center, art gardens, pools, and play areas. The character broke the scale down with multiple buildings, private decks, and varied exterior finishes. The architect, Miller Hull Partnership of Seattle, Washington, was the 2003 American Institute of Architects Firm of the Year. (Author's collection.)

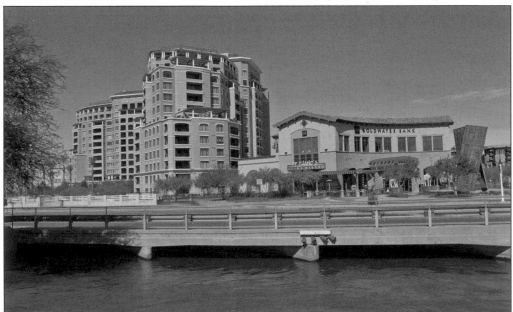

WATERFRONT. This 2007 large mixed-use development includes retail, restaurants, offices, and luxury residential condominiums within 13 stories, which made it the highest structure in Scottsdale. Eclectic styling was provided with plaster walls, tile roofs, and ornate columns. Stepped upper walls, exterior terraces with shade canopies, and two-story retail to the streets all mitigated such heights. The design was generated by Solomon Cordwell Buenz and Associates, Inc. along with associate architect H and S International, LLC. (Author's collection.)

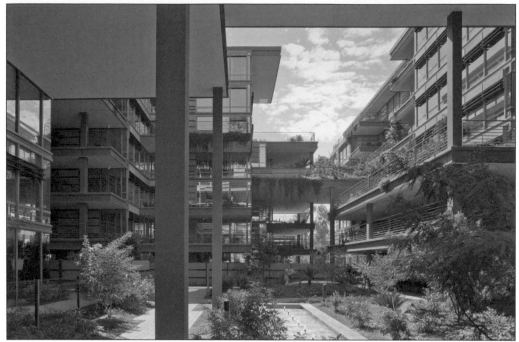

OPTIMA CAMELVIEW VILLAGE, 2007. Optima Camelview Village, located at 7177 East Rancho Vista Drive, is a 1.1-million-square-foot and seven-level development that includes over 700 luxury residential units, a fitness center with swimming pools, parking below, and street-level retail. The exposed steel structure is stacked with variety to reduce the overall massing while interconnecting outdoor spaces with such sculpted forms. Extensive landscaped terraces and roofs minimize contributing to the urban heat island factor. Architect David C. Hovey, FAIA, designed the development. (Jerry Portelli Photography; Optima, Inc.)

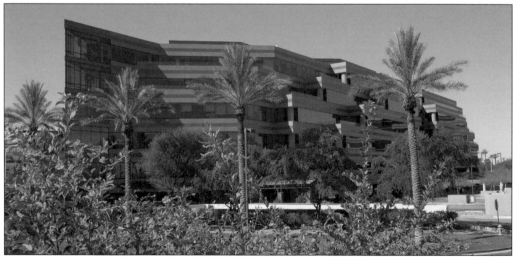

FINOVA, 1999. The Finova office structure was constructed at the north edge of downtown and included a restaurant and offices. The building is stepped in section, integrated balconies and had angled corners that mitigated the volume. Views are oriented toward Camelback Mountain and downtown. The exterior is clad in a warm granite and tinted glass. The architect was Cornoyer-Hedrick, Inc. (Author's collection.)

DAVID MICHAEL MILLER ASSOCIATES, 1999. David Michael Miller Associates (DMMA), a 1,800-square-foot interior design studio, is located at 7034 East First Avenue. "Interior and exterior read together through light, materiality, and transparency. The urban room created by the vitrine, canopy, and garden setting contribute to the vitality of the street life in this pedestrian-friendly cultural arts district of downtown Scottsdale," as stated by architect Wendell Burnette, AIA, of Wendell Burnette Architects; DMMA provided the interior design. (Timothy Hursley, Wendell Burnette Architects.)

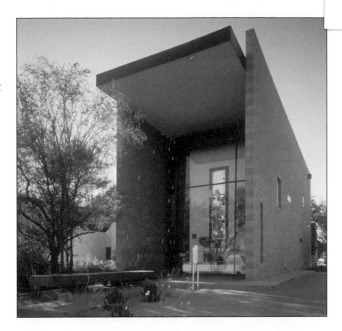

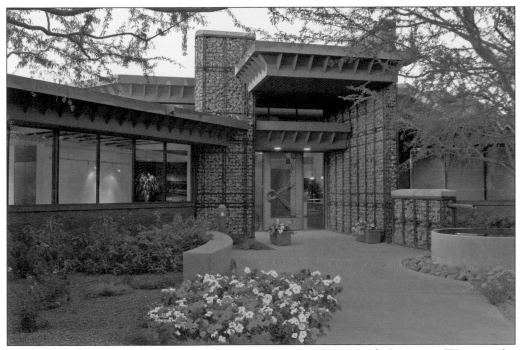

LINTHICUM CONSTRUCTORS HEADQUARTERS, 1996. At 17700 North Pacesetter Way was the headquarters of Linthicum Constructors, a progressive construction company. Priority was "to establish a building of distinctive character that demonstrated . . . the craftsmanship, skills, innovative use of building materials, corporate philosophy, and respect for the desert region . . . Client wanted to break the mold of what they sensed was a lack of responsive design with respect for the Sonoran Desert environment," as stated by architect John Sather, AIA, AICP, of Vernon Swaback Partners. (Mark Laverman; Linthicum Constructors; Vernon Swaback.)

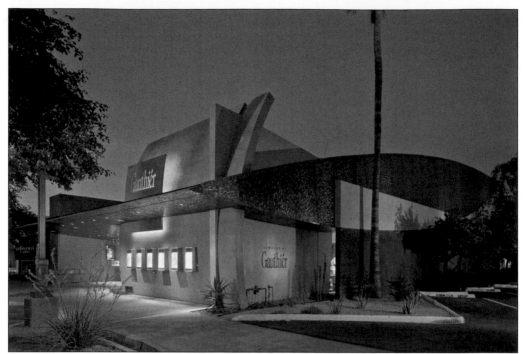

GAUTHIER JEWELRY, 2001. At 4211 North Marshall Way in downtown was a remodel and second-story addition to an existing gallery for Gauthier Jewelry. The character was sculpted not unlike the contemporary jewelry being created. The sweeping roof form is low-scaled at the street for pedestrians and rises as it moves away. Special detailing includes the display cases, dramatic lighting, signage, and natural finishes. Architekton provided the design for this project. (Architekton.)

INA LEVINE JEWISH COMMUNITY CAMPUS, 2002. The 35-acre Ina Levine Jewish Community Campus provided a 114,000-square-foot community center. The design by architect Langdon Wilson alluded to the Star of David, the 12 tribes of Israel, and Jerusalem's Western Wall. The exterior used a palette of natural materials such as the concrete panels, steel roof framing, and stone accent walls. The building form is expressionistic with angular walls, playful wall cutouts, and recessed glazed panels. (Langdon Wilson.)

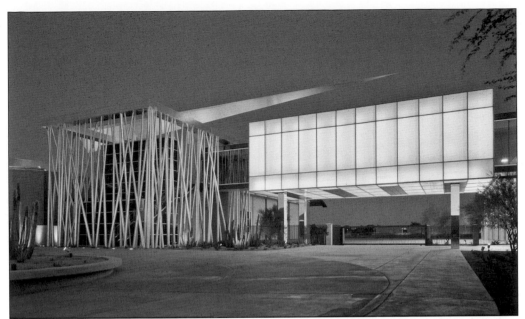

HANGER ONE, 2003. The 5.5-acre site of Hanger One is located at 15220 North Seventy-Eighth Way in the Scottsdale Airpark. The program included a 140,000-square-foot private hanger for 15 aircraft with a flight club, office, private auto gallery, and entertainment space. The blending of a concrete structure, aluminum, stainless steel, translucent panels, and a roof-mounted aluminum "paper" glider made for a fresh architecture. There was a collaborative design effort between architects Vernon D. Swaback, FAIA, and Adam Tihany of New York. (Paul Warchol, Swaback Partners, pllc.)

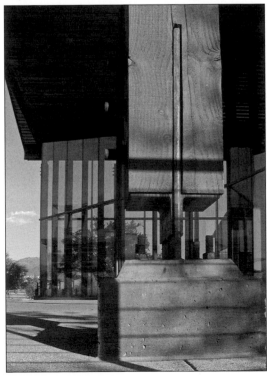

BUILDING O AT MARKET STREET, 2003. The 10,593-square-foot Market Street office development is located at 20645 North Pima Road on the historic D. C. Ranch desert property. Circle West Architects offered a fresh balance to historic ranching structure references and a contemporary interpretation of concrete, rusted steel features, metal siding, and detailing. (John Wagner Photography; Circle West Architects.)

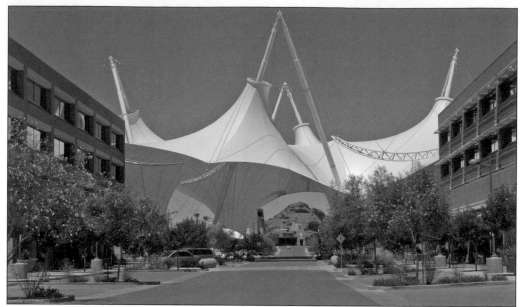

SKYSONG, 2008. The southeast corner of Scottsdale and McDowell Roads was the former Los Arcos Mall, and now it is the 300,000-square-foot Phase I and II Arizona State University Scottsdale Innovation Center at the master development called Skysong. Two office and research facilities catering to internationally active companies expressed a utilitarian flexibility. The north and south walls provided recessed windows, while the east and west ends minimized the solar heat gain. The structures flanked a tree-lined street that led to the 2009 tensile fabric structure that stands at 125 feet high. Pei Cobb Freed Architects and DMJM Design worked on the buildings, and FTL Design Architects and FabriTec Structures was responsible for the fabric piece. (Author's collection.)

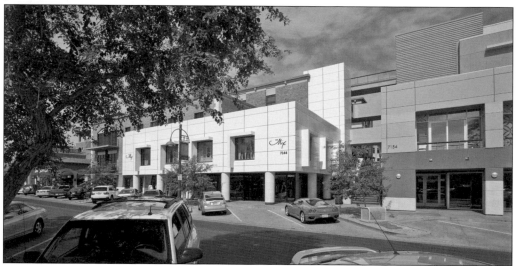

SOUTHBRIDGE DEVELOPMENT, 2008. The mixed-use Southbridge development has retail and restaurants at lower levels fronting Stetson Drive and office condominiums above that overlook the Arizona Canal. Four building components of varying characters attempted to capture a structure that evolved over a longer period of time than in actuality, which breaks down the overall scale. Allen and Philp Architects designed this mixed-use development. (Allen and Philp Architects.)

HENKEL HEADQUARTERS, 2009.
At 19001 North Scottsdale
Road is the four-level corporate
headquarters and research
facility of Henkel designed by
Will Bruder + Partners, Ltd.
Contemporary character uses
include concrete walls, ribbed
panels, fritted glass, aluminum
mullions, entry concrete beam,
and fiberglass wrapped columns.
The upper roof suggests the desert
rising as it is fully developed with
shade trees, serpentine granite
pathways, and raised flagstone
planters. The interior atrium is
a tall volume with suspended
open stairways, bridges, and
a skylight. (Bill Timmerman,
Will Bruder + Partners, Ltd.)

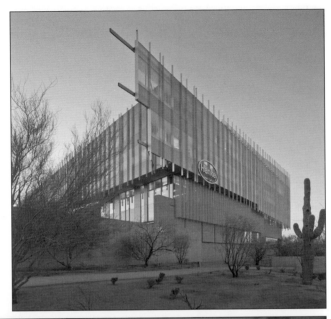

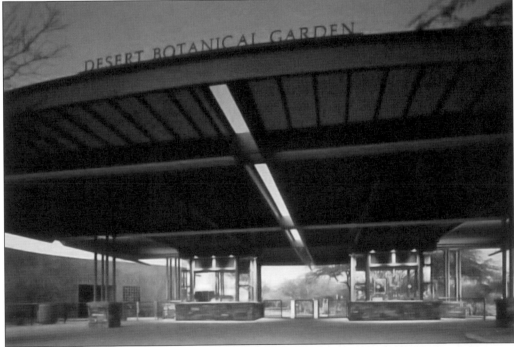

DESERT BOTANICAL GARDEN, 2002. The 160-acre Desert Botanical Garden was founded in 1938 and has earned an international reputation for its botanical displays and horticultural research. An expansion at 1201 North Galvin Parkway includes an entry pavilion, library, Dorrance Hall, education center, gift shop, and sales greenhouse. "Design work . . . grew out of investigations into important issues, such as maintaining the 'garden environment,' and not allowing the new buildings to overpower this subtle experience," as stated by architect John Douglas, FAIA. Christy Ten Eyck, FASLA, and Steve Martino, FASLA, were the landscape architects for the project. (Bill Timmerman, Douglas Architects.)

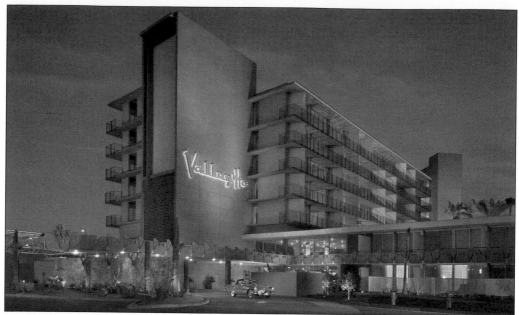

VALLEY HO ADDITIONS AND RENOVATION, 2005. At 6850 East Main Street, additional levels were provided to the Valley Ho per the original 1956 drawings. The renovation retained the original character by salvaging existing wings and the courtyard. Original brick walls, concrete railings, and fascia as well as custom steel open stairs of triangular patterns were preserved. The new additions made by Allen and Philp Architects included condominiums, a conference center, and recreating Trader Vic's Restaurant. (Allen and Philp Architects.)

W HOTEL AND RESIDENCES, 2008. This 300,000-square-foot mixed-use development is located at 7277 East Camelback Road. Its uses include 224 guest rooms, 18 luxury residences, 3 bars, a spa and restaurant with a second-level swimming pool, a beach, and lounge that captures views. W Scottsdale is contemporary with regional roots, as split-face stone, recessed windows, and trellises were used by architectural firm Hornberger + Worstell of San Francisco, California. (Author's collection.)

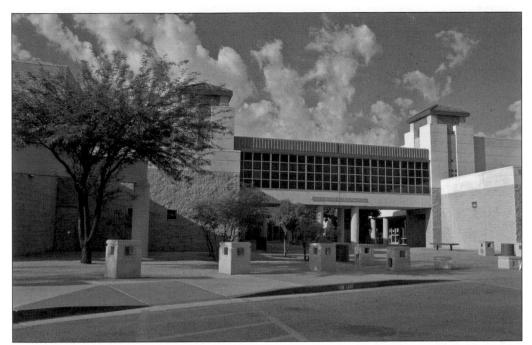

DESERT MOUNTAIN HIGH SCHOOL, 1995. The Desert Mountain High School campus for grades nine through eleven is located at 12575 East Via Linda on a desert site. The site plan was sensitive to the vegetation by respecting the drainage washes: buildings held tighter to the streets and ball fields were at lower slopes. Character was post-modern with split-face masonry, plastered walls, grills, and colored accents. The Lescher and Mahoney/DLR Group architecture firm that designed the high school was also responsible for the adjacent 1996 Desert Canyon Middle School. (Author's collection.)

APPLIED SCIENCES CLASSROOM BUILDING, 1998. Two structures totaling 47,000 square feet are located at 9000 East Chaparral Road on the Scottsdale Community College campus. Twelve different departments were accommodated including culinary arts, interior design, film and television studios, drafting, restaurant management, and others. Architects did respect a master plan and created a socialization courtyard defined by shade, seating, and landscape. The architects for this project were Wyatt/Rhodes Architects and Douglas Sydnor Architect and Associates, Inc. (Mark Boisclair Photography, Douglas Sydnor Architect and Associates, Inc.)

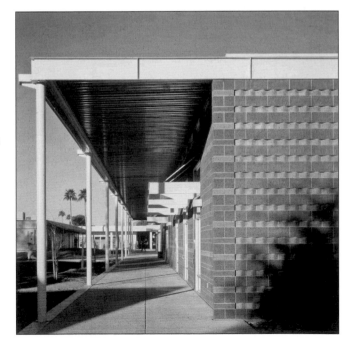

LANGUAGE AND COMMUNICATIONS BUILDING, 1999. This 28,000-square-foot building is located at 9000 East Chaparral Road on the Scottsdale Community College campus. Its uses included classrooms and labs. The architecture plan by Gould Evans Associates, LC focused on a courtyard that integrated the classroom environment with flexible outdoor spaces. Exposed masonry, metal siding and roofing, and site improvements make for a crafted and durable result. Gould Evans Associates, LC was also responsible for the 1999 Math and Computer Information Systems (CIS) Building. (Gould Evans Associates, LC.)

FOOTHILLS ACADEMY COLLEGE PREP, 2002. Foothills Academy College Prep, a 19,075-square-foot private high school, is located on 5.77 acres at 7197 East Ashler Hills Drive in the northern desert. It has a sustainable focus, including preserving native landscape, using plastered 24-inch straw-bale walls, natural daylighting, and energy-efficient systems. Architect Philip Weddle, AIA enrolled the project in the City of Scottsdale Commercial Green Building program. (Bill Timmerman, Weddle Gilmore Architects.)

FITNESS CENTER, 2000. The Scottsdale Community College campus fitness center is located at 9000 East Chaparral Road. This 27,000-square-foot replacement facility includes a center for health, wellness, and physical fitness that serves the students, faculty, staff, and public. Architekton used a premanufactured steel structure but visually improved it with curved copper walls, masonry column covers, and horizontal louvers at porch spaces. (Architekton.)

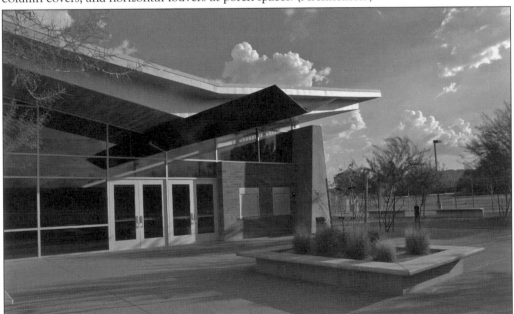

CHAPARRAL HIGH SCHOOL, 2008. The Chaparral High School at 6935 East Gold Dust Avenue was originally for grades nine through eleven until 1973, when grade twelve was added. The original high school has undergone a series of additions and renovations over the years, including this modernization program by the Orcutt Winslow Partnership architectural firm with new two-story classroom wings, a cafeteria, laboratories, administration offices, and extensive site improvements. The materials are exposed masonry, metal siding, glazing, and fencing. (Author's collection.)

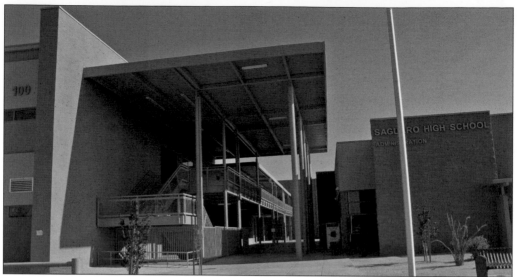

SAGUARO HIGH SCHOOL MODERNIZATION, 2008. At 6250 North Eighty-Second Street, a major expansion and renovation of the existing Saguaro High School campus took place with new two-story classrooms and laboratories; one-story administration offices; and a remodeled auditorium, gymnasium, and cafeteria. The character reflects a pragmatic and functional approach, and the construction consists of masonry walls and steel framing at shade canopies, open stairs, and balconies. The architect for this modernization was DLR Group. (Author's collection.)

CORONADO HIGH SCHOOL MODERNIZATION, 2008. The Coronado High School modernization included a major expansion and renovation of the existing campus located at 2501 North Seventy-Fourth Street. Its uses include new classrooms, laboratories, administration offices, an auditorium, and an existing gymnasium remodel and new ball fields. This view shows an original mosaic that celebrated all the art forms by Joseph Gatti, former art teacher, which was salvaged, restored, and integrated into the new auditorium. The exterior used multicolored masonry, metal siding, and glazed areas. The architect for this modernization was DLR Group. (Author's collection.)

McDowell Mountain Community Church. The 2006 McDowell Mountain Community Church located at 10700 North 124th Street used exposed concrete masonry units in a geological layered pattern, plaster, sculptural forms, and a butterfly entry canopy. This expressionistic religious facility by Barduson Architectural Group was reminiscent of some earlier 1960s precedents. (Author's collection.)

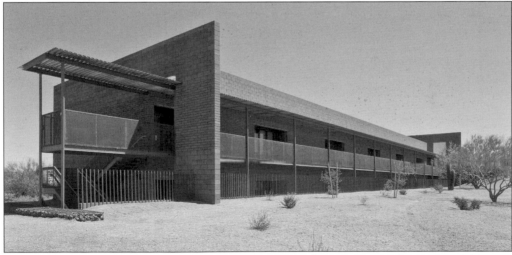

Scottsdale First Assembly, 2006. This 28,420-square-foot structure is located on 26.2 acres at 28700 North Pima Road. Its uses include a 1,000-seat worship space and administration and educational programs. "Building massing is set up as a series of parallel north/south walls that cut into the site. Infill planes are glass and corten panels of weathered steel walls and dark integral color masonry. In addition it was to "create a palette of quiet materials that allow the native desert vegetation and topography to be clearly read in the context," as stated by architect Jack DeBartolo III of DeBartolo Architects, Ltd. (Bill Timmerman, DeBartolo Architects Ltd.)

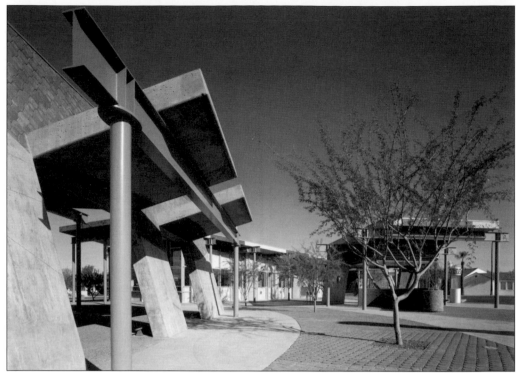

LOLOMA TRANSPORTATION CENTER, 1998. The multimodal Loloma Transportation Center is located on 2 acres at 7084 East Second Street and brought a new energy with a public plaza, Palo Brea trees, shade canopies with coolers, and a landmark clock tower. Within the tree canopies are sculpted structures that appear to have the ground plane folded up to form angled walls and folded once again to create roofs. Douglas Sydnor Architect and Associates, Inc. and public artist Vito Acconci collaborated on this project. (Mark Boisclair Photography; Douglas Sydnor Architect and Associates, Inc.)

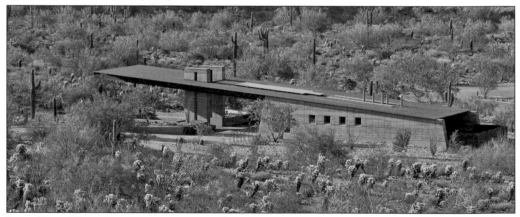

LOST DOG WASH TRAILHEAD, 2006. The Lost Dog Wash Trailhead facility located at 12601 North 124th Street delivered a desert-sensitive structure of rammed-earth walls and a rusted-steel structure. An appropriate and sustainable architecture was provided for the upper Sonoran Desert, accomplished within minimal means and requiring less energy than conventional construction. Architect Philip Weddle, AIA, designed this trailhead and the Pinnacle Peak Trailhead. (Bill Timmerman; Weddle Gilmore Architects.)

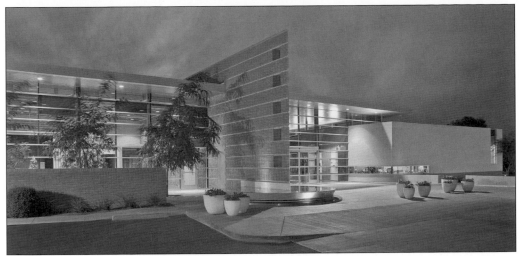

GRANITE REEF SENIOR CENTER, 2006. The Granite Reef Senior Center is located on 13 acres at 1700 North Granite Reef Road and includes 37,500 square feet. Its uses include a multipurpose facility for social services, health and wellness, and recreational functions. It was the first LEED Gold Certified facility in the city. "With its central plant, solar panels, super-insulated roof, and extensive use of daylight, it has established a new energy conscious standard for Scottsdale's facilities," as stated by architect Jan Lorant, AIA, of Gabor Lorant Architects, Inc. (Chris Loomis Photography; Gabor Lorant Architects, Inc.)

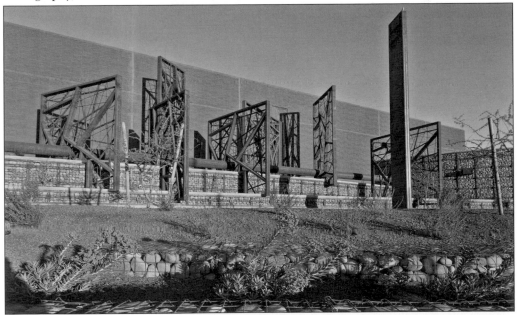

CHAPARRAL WATER TREATMENT FACILITY, 2007. The city's water treatment facility at 7550 East McDonald Drive was built on 29 acres and includes 71,000 square feet, a public park, trails, xeriscape gardens, and a dog park. To reduce the massing, one story was below grade and one was above. The design used "intense sunlight and the geometric character of the desert . . . to fully utilize the riches from shade and shadow playing off a simple palette of rugged, timeless materials," as stated by architect John Sather, AIA, AICP, with Swaback Partners, pllc. (John Trotto; Swaback Partners, pllc.)

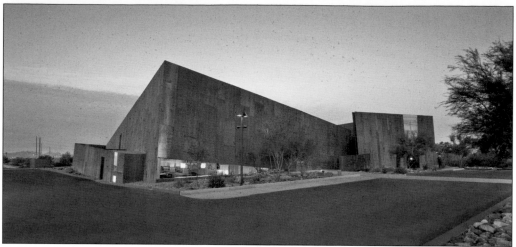

ARABIAN BRANCH PUBLIC LIBRARY, 2007. The Arabian Branch Public Library is on 4 acres at 10215 East McDowell Mountain Ranch Road and includes 20,000 square feet. Its functions include collections, meeting rooms, story time, teen area, study rooms, computer lab, and an early literacy center. The design by Richard + Bauer Architecture used a metaphorical reference to northern Arizona slot canyons with narrow, tall spaces open to the sky and angled side walls, all of which led to a defined courtyard. (Scottsdale Public Library.)

MARSHALL WAY BRIDGE AT ARIZONA CANAL, 2007. A 9,500-square-foot multiuse plaza for pedestrian use, trolley access, and public events linked downtown's Fifth Avenue to the Waterfront project. The well-scaled Marshall Way Bridge is steel with shade panels and copper planters and was supported with a carbon-fiber reinforced concrete bridge. The bridge designed by architect John Douglas, FAIA has helped redevelopment and has been used for numerous events. (Steve Martino, FASLA; Douglas Architects.)

MᴄDᴏᴡᴇʟʟ Mᴏᴜɴᴛᴀɪɴ Rᴀɴᴄʜ Aᴏᴜᴀᴛɪᴄs Cᴇɴᴛᴇʀ, 2007. The 24,000-square-foot McDowell Mountain Ranch Aquatics Center is located at 15525 North Thompson Peak Parkway and includes a community room, fitness center, dance and aerobics studios, three swimming pools, and a skate park. The character is contemporary with a higher entry form, lower-scaled wings, and a secured pool area. The materials include cast concrete, rusted-metal panels, and fabric shades. Architect Philip Weddle, AIA, designed the aquatics center. (Bill Timmerman; Weddle Gilmore Architects.)

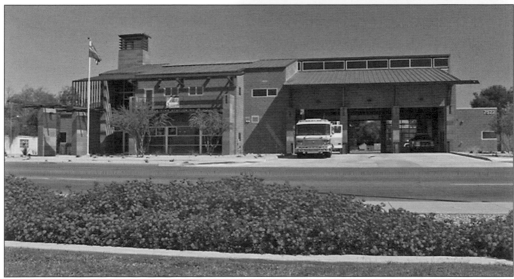

Dᴏᴡɴᴛᴏᴡɴ Fɪʀᴇ Sᴛᴀᴛɪᴏɴ Nᴏ. 2, 2008. The downtown fire station is located at 7522 East Indian School Road. The structure is constructed of masonry, sandstone piers, steel framing, rusted-metal roofing, and tinted glazing. The project is certified LEED Platinum Level with a well-insulated envelope, rainwater harvesting, drought resistant landscaping, permeable paving, and a cooling tower that serves a community room and exterior patio. The architect was Lawrence Enyart, FAIA, of LEA-Architects, LLC. (Lawrence Enyart, FAIA, LEA-Architects LLC.)

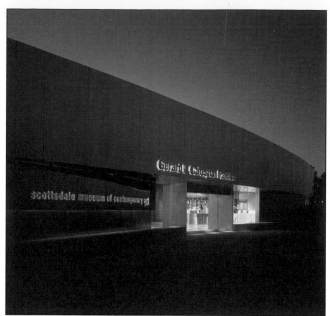

SCOTTSDALE MUSEUM OF CONTEMPORARY ART, 1999. The Scottsdale Museum of Contemporary Art is located at 7380 East Second Street and includes renovations and additions. The existing structure was transformed by William P. Bruder Architects into four flexible galleries that exhibit contemporary art, architecture, and design. The exterior patio integrated the *Scrim Wall* by public artist James Carpenter. The exterior materials include curved-zinc walls, frameless glazing, and interior materials consisted of exposed wood roof framing, steel panels, and concrete floors. (Bill Timmerman; Will Bruder + Partners.)

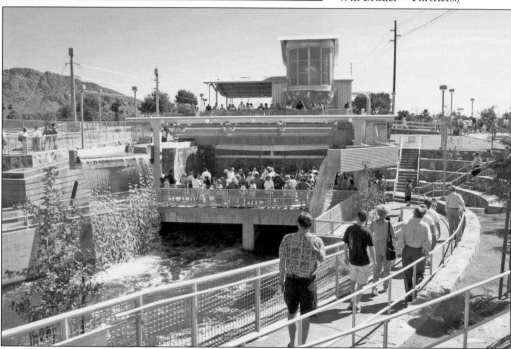

WATER WORKS AT ARIZONA FALLS, 2003. The concept for the Water Works structure was to celebrate the historic Arizona Falls by retaining some of the original walls, maintaining the falls by letting gravity continue to do the work, and providing interpretative public information. The materials included concrete, steel framing, and corrugated-metal siding/roof. Concluding *Scottsdale Architecture* with this Arizona Canal improvement is appropriate as this is where Scottsdale all began, with the canal, which provided that critical water resource to local farms. Artists Lajos Heder and Mags Harries of Boston, Massachusetts, collaborated on this project. (Salt River Project Research Archives.)

BIBLIOGRAPHY

Central Arizona Chapter, American Institute of Architects. *A Guide to the Architecture of Metro Phoenix*. Phoenix, AZ: self-published, 1983.

Fudala, Joan. *Historic Scottsdale: A Life from the Land*. San Antonio, TX: Historic Publishing Network, 2001.

———. Images of America: *Scottsdale*. Charleston, SC: Arcadia Publishing, 2007.

Myers, Patricia Seitters. *Scottsdale: Jewel in the Desert*. Windsor Publications, Inc., 1988.

Municipal Chronology. Scottsdale, AZ: City of Scottsdale, April 30, 2007.

Historic Significance and Integrity Assessment Reports for Listing on the Scottsdale Historic Register. Scottsdale, AZ: City of Scottsdale Preservation Division, various dates.

www.arcadiapublishing.com

Discover books about the town where you grew up, the cities where your friends and families live, the town where your parents met, or even that retirement spot you've been dreaming about. Our Web site provides history lovers with exclusive deals, advanced notification about new titles, e-mail alerts of author events, and much more.

Find Your Place in History.